IMAGES
of America

CHICAGO'S
MAXWELL STREET

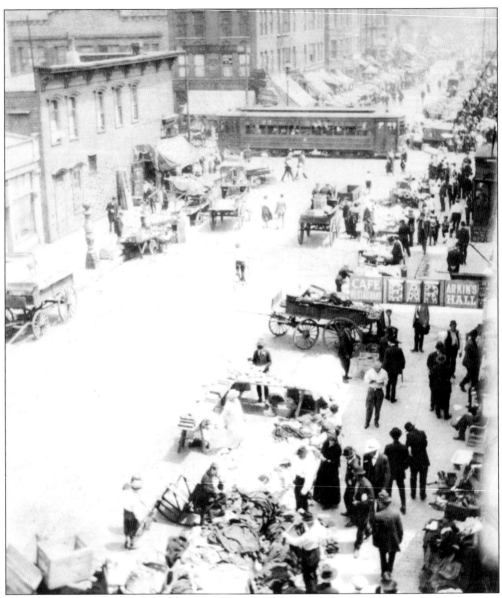

Throughout the history of the Maxwell Street market, Halsted Street has served as a major gateway to the market area. Halsted Street is also "Illinois Highway 1" and begins at the southern border of Illinois and terminates in the city of Chicago. This early 20th-century view east on Maxwell Street shows a Halsted street car crossing a busy market lined with peddlers' wagons, tables, pushcarts, and shoppers. The market was also bounded on the east by a street car line at Jefferson Street, which created a condensed marketplace for several blocks along Maxwell Street. (Courtesy of Special Collections, the University Library, University of Illinois at Chicago, Marcy-Newberry Records—M-N neg. 154, undated.)

Cover: The Maxwell Street market in full blast, looking east along the 700 block. (Courtesy of Edward C. Schulz from his unpublished thesis *A Functional Analysis of Retail Trade in the Maxwell Street Market Area of Chicago*, 1954.)

IMAGES
of America

CHICAGO'S MAXWELL STREET

Lori Grove & Laura Kamedulski

for the Maxwell Street Historic Preservation Coalition
in association with the Chicago Historical Society

ARCADIA

Published by Arcadia Publishing,
an imprint of Tempus Publishing, Inc.
3047 N. Lincoln Ave., Suite 410
Chicago, IL 60657

Printed in Great Britain.

Library of Congress Catalog Card Number: 2002110132

For all general information contact Arcadia Publishing at:
Telephone 843-853-2070
Fax 843-853-0044
E-Mail sales@arcadiapublishing.com

For customer service and orders:
Toll-Free 1-888-313-2665

Visit us on the internet at http://www.arcadiapublishing.com

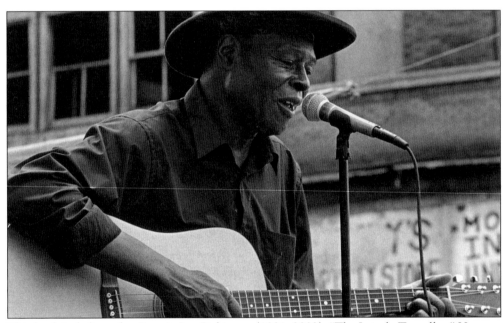

This book is dedicated to Jimmie Lee Robinson (1931–2002), "The Lonely Traveller." He grew up near the Maxwell Street neighborhood and spent most of his life playing acoustic guitar and singing on its streets, beginning in the early 1940s. He recorded as a side-man for blues artists such as Eddie Taylor, Freddie King, Little Walter Horton, Sunnyland Slim, and Howlin' Wolf.

"Maxwell Street Tear Down Blues" was written and recorded by Jimmie Lee to inspire the effort to preserve old Maxwell Street. Robinson was active in this effort, even going on an 81 day hunger strike for the cause. In 2000, he performed his song in an unprecedented presentation to the Illinois Historic Sites Advisory Council in support of a Maxwell Street Historic District nomination to the National Register of Historic Places. (Courtesy of photographer, James Fraher, 1999.)

CONTENTS

ACKNOWLEDGMENTS

We are grateful to the members and supporters of the Maxwell Street Historic Preservation Coalition (MSHPC), who have donated their time and energy to the cause of saving Maxwell Street. The mission of the MSHPC is to advocate for the preservation of the character, heritage, and built environment of the old Maxwell Street neighborhood on Chicago's Near West Side and to preserve and interpret the history of Maxwell Street for future generations. Without the efforts of Coalition members to photograph and document Maxwell Street and community action through many means, including the website at www.maxwellstreet.org, we could not tell this complete story. The Coalition has also been active in the collection of architectural fragments and ephemera from the street's built environment for a future archive and museum. We thank our Officers and Directors, Chuck Cowdery, Steve Balkin, Elliot Zashin, Alan Mamoser, and Bill Lavicka for the planning and editing of this book, and Janelle Walker, Michael Moran, Daniel Marmer, and May Weber for their general support.

This book was completed in association with the Chicago Historical Society (CHS). Without their contribution of a large selection of Maxwell Street photographs, this book could not have been realized. The CHS is committed to partnerships with organizations in several Chicago neighborhoods to support local history projects and views this book as a continuation of work on Chicago's West Side that began with the Neighborhoods: Keepers of Culture project in the 1990s. We are grateful to the CHS for helping to make the history of Maxwell Street accessible, which is appropriate for a place comprised of generations of working class people. We'd especially like to thank Russell Lewis, the Andrew W. Mellon Director for Research and Collections, for his generosity and responsiveness to Maxwell Street preservation efforts. Darmon Lewis and Lesley Martin were extremely helpful in finding materials in the Research Center. Rob Medina, Keshia Nedellin, and Caroline Nutley have been a pleasure to work with in accessing materials and ordering prints in the rights and reproduction area. Photographers John Alderson and Jay Crawford are to be commended for their skills and diligence in printing a large number of photos for our effort.

Many others deserve our gratitude for lending support or their images for publication and, for the photographers among them, for the quality of their photographic work. They are: James Iska, Jack Davis, Art Shay, Ron Gordon, Ronald Seymour, Jeff Fletcher, Ray Flerlage, James Fraher, Lee Landry, Sheila Malkind, Michael Mauney, Linda Baskin, Martin C. Tangora, Dan Miller, Merlyn McFarland, Steve Sexton, Steven Balkin, the Bremner family, the Goldberg family, Chelle Mollohan, Nancy Buenger, Irving Cutler, Carolyn Eastwood, Ira Berkow, Sheldon Robinson, Joan Breyer Gould, Joel Helfand, Margaret Mantle, Wendy Plotkin, Tony and Lupe Hernandez, Tawnya Michie Kumarakulasingam, Judith Hayes, Christopher L. Stratton, Edward C. Schulz, William S. Bike, Mary Somogy, Lionel Trepanier, Wes Wager, Tyner White, Mike Meesig, Lorenz Lessin, Karen Poulson, Reverend John D. Walker, Steve Burnett, Sidney Williams, Lili Ann Mages Zisook, Shirlee Gold Mages, Kiyoko Lerner, Gene Mackevich, Joseph Stefanovic, Alan and Irving Federman, Gus, Judy, and Jim Christopoulos, Tom McGlade, James Eisenberg, James Bodman, Frank McMenamin, John McNalis, Ken Little, Lance Grande, Elaine Zeiger, Lorie Barber, Michael Williams, Nice Card Company, Firestar Communications, Lake Claremont Press, Dare Foods Limited, and the City of Chicago's Department of Consumer Services and Transit Authority. We are also appreciative for the research assistance provided by Patricia Bakunas at the University of Illinois at Chicago Special Collections, Patrick Morris at the Newberry Library, Susan Sacharski at the Northwestern Memorial Hospital Archives, Debra Gust at the Lake County Discovery Museum, Meredith Taussig at the Commission on Chicago Landmarks, and especially Norman D. Schwartz at the Chicago Jewish Historical Society. Finally, we thank our Arcadia editor, John Pearson, who has been exceptionally accommodating with the development and preparation of this book.

Our families have been extremely helpful in our efforts. Laura Kamedulski's husband, David, has been a tolerant trouble-shooter at the computer and a loving supporter. Her son, Jackson, has occupied himself through her hours of computer time and provided frequent breaks from work. Laura's mother, Linda Hempfling, has devoted many hours of her time to watching Jack, by which she has assisted this work's completion to coincide with the birth of his new sister, Sonja. Lori Grove's husband, Lee Weitzman, whose furniture studio once overlooked the Maxwell Street market area, introduced her to the urban phenomenon she has since sought to research and preserve.

INTRODUCTION

Many Chicagoans hold an enduring love for Maxwell Street, one of the city's distinct landmarks, even now that its physical fabric is largely removed. The story of Maxwell Street and its market is the story of immigrants and their children, generations of working class people who contributed to the advancement of our nation. The famous area became the "Ellis Island" of the Midwest, drawing immigrants from all over the world, and a "Promised Land" for migrants from distant parts of America.

The Maxwell Street area was a viable center for low-income and minority businesses and shopping for nearly a century, but the market lacked the clout to preserve its integrity. First, the construction of the Dan Ryan expressway and urban renewal cleared a large part of the market area in the 1950s and 1960s. In 1990, the University of Illinois at Chicago (UIC) published its master plan that included a south campus expansion into the Maxwell Street area. In 1994, the Maxwell Street market was relocated to nearby Canal Street, and the UIC began actively purchasing and clearing properties, utilizing the power of eminent domain when needed. People from many communities throughout the city and the nation opposed the displacement, or vied for inclusion in the UIC's redevelopment plan, to little avail.

The residents and businesses are gone from the neighborhood now, and almost all of the buildings that once lined Roosevelt, Maxwell, Halsted, and adjacent side streets have been razed. UIC is recreating the area according to an institutional aesthetic. An agreement between the university and the city calls for a few building renovations and façade restorations. Yet many believe Maxwell Street will survive in memory because of people's strong attachment to the place. It is where so many entrepreneurs grew up or got their start, while even larger numbers visited to find a good bargain, mill in the crowds, eat the famous hot dogs and polish sausages, or listen and dance to blues and gospel music. It was a place to see the mundane and the fantastic, from piles of second-hand junk to distinctive vendors, street performers, and religious proselytizers. Within the urban environment of Chicago, Maxwell Street was known as a place for spontaneity and a pervasive feeling of friendliness, as a place where everyone, regardless of race or ethnicity, shared the public space together.

Maxwell Street will live on in many minds as an incubator for business and the electrified Chicago Blues, a starting place for working class immigrants and migrants, and as a great streetscape for its shops and outdoor market. Its resilient character evolved through decades of transformation. With this book, we commemorate the history of Maxwell Street and Chicago's longest standing open-air market.

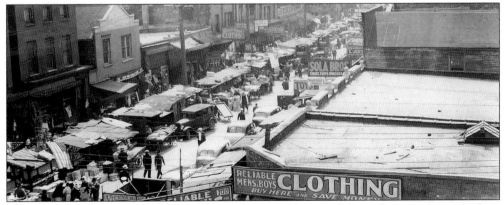

This view west shows the last block of contiguous buildings on Maxwell Street, from which the last business closed in 2002. (Courtesy of CHS, ICHi-35184, 1939.)

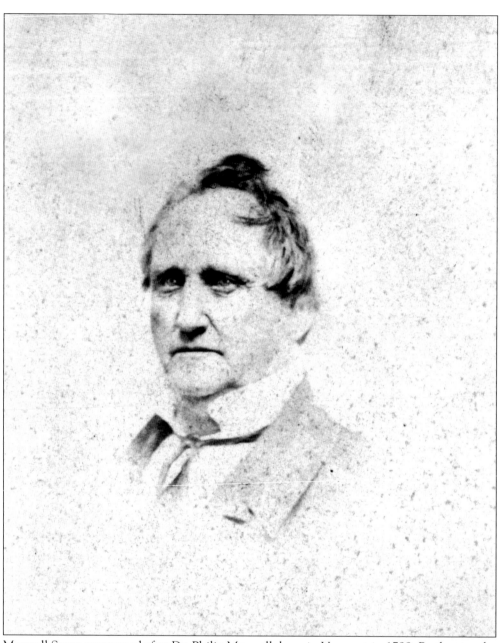

Maxwell Street was named after Dr. Philip Maxwell, born in Vermont in 1799. By the time he arrived at Chicago's Fort Dearborn as an assistant surgeon in the United States Army, he was one of a handful of people in 1832 who made the village of Chicago their permanent residence. When the fort was abandoned in 1836, Dr. Maxwell resigned from the army to stay in Chicago and took a partnership in medical practice with Dr. Brock McVickar at Lake and Clark Streets. "His broad and massive face…was usually beaming with mirth," it was written. "He was," said the *Chicago Republican* in 1863, "one of nature's noblemen. He was of that choice material which God makes to follow the first rough work of the pioneers in laying the foundation of a new society." Dr. Maxwell died at his country place in Lake Geneva, Illinois in 1859.

One

THE MARKET

The Maxwell Street market, created by a city ordinance in 1912, changed one of Chicago's early residential streets into a thriving marketplace for almost a century. Although the geographic boundaries of the marketplace shifted during nine decades of activity, the structure of informal bartering on Maxwell Street and discount shopping on Halsted Street remained constant. The roots of the market in Old World European traditions, transplanted into the urban environment of Chicago, created a distinctive marketplace that became known worldwide. The market, the types of businesses, and the store architecture evolved into a shopping experience where the diversity of the vendors, merchants, crowds, and merchandise created a character unique to Maxwell Street. Many business entrepreneurs were born and raised here, or developed their businesses here, and made significant contributions to our city and nation through their innovations, ingenuity, and resourcefulness.

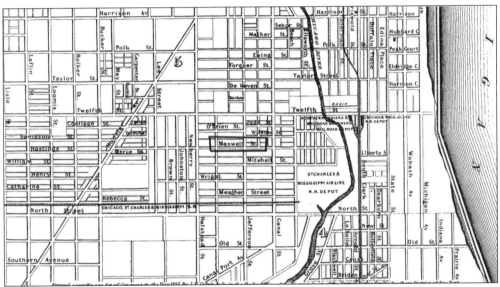

The area south of 12th Street (now Roosevelt Road) and west of the Chicago River that includes Maxwell Street (located on the center of this map), was within the boundaries of the City of Chicago when incorporated on March 4, 1837. Originating at the south branch of the river, Maxwell Street extended to Halsted Street in 1849 and then to its current terminus at Blue Island Avenue by 1855. During this time, the area was an early settling ground for newcomers arriving on emerging train lines along the east shore of the river. The easternmost section of Maxwell Street near the river was largely used for lumber yards, and the early residential settlement of frame cottages stretched westward from the vicinity of Canal Street. Residences were first documented on Maxwell Street in the 1860s, some of which were homesteads. (Courtesy of the Newberry Library, Chicago, *The City of Chicago, Illinois*, map from J.H. Colton, 1855.)

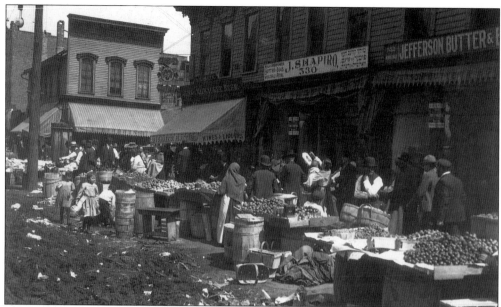

Many of the early views in the Maxwell Street area are actually along Jefferson Street near the Maxwell Street intersection. In 1906, Sam Harris' Place (a saloon), Jacob Shapiro's store, and the Jefferson Butter and Eggs business were located on the southeast corner of Jefferson and Maxwell (now 1331-1333 S. Jefferson). The long, frame building that housed these businesses was opposite Hattie Rubinsky's grocery store shown on the northeast corner (now 570 W. Maxwell). (Courtesy of the CHS, ICHi-34422, by Charles R. Clark, 1906.)

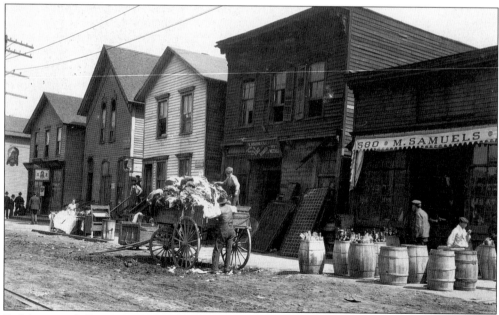

B. Morris and Co., a rag seller located two blocks south of Maxwell Street (now 1429 S. Jefferson), neighbored M. Samuels' grocery store in 1906. The peddler's wagon with heaps of rags was a common sight in the Maxwell Street vicinity. The selling of rags for reprocessing was a standard means of living for area residents. (Courtesy of the CHS, ICHi-34416, 1906.)

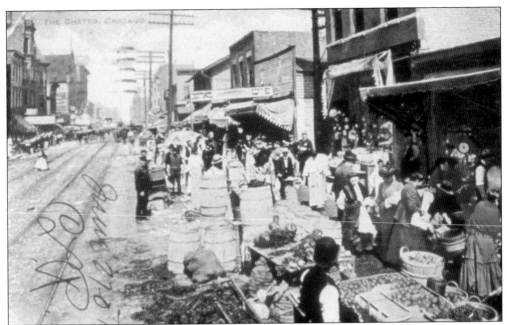

S. Sigal's crockery, shown second in the foreground, was located on Jefferson Street in the block north of Maxwell Street. Jefferson Street had a street car line, and the traffic attracted peddlers to set up wares and shops along the busy street. This background grouping of buildings is associated with early Maxwell Street, but it is actually Jefferson Street near the intersection of Maxwell Street. (Courtesy of the CHS, ICHi-19155, by Barnes-Crosby, c. 1905.)

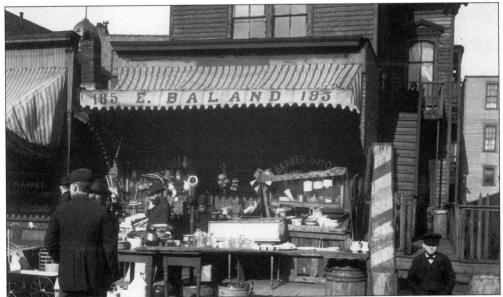

As Jefferson Street became busier and more crowded, particularly after the Great Chicago Fire of 1871, the peddling activity spilled over onto Maxwell Street where many of the Jewish residents accommodated the overflow by setting up retail operations in front of their small residential cottages. Here, a brick addition to a frame residence serves as a barbershop and an outdoor stand. (Courtesy of the CHS, ICHi-34418, by Charles R. Clark, c. 1906.)

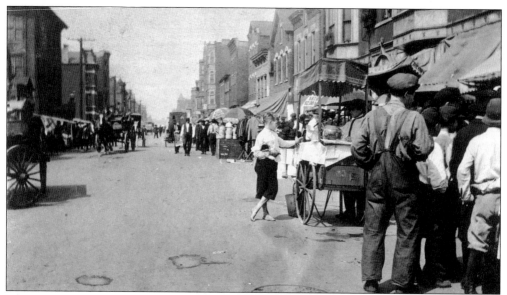

In 1912, the City of Chicago passed an ordinance that created a public market on Maxwell Street and the office of superintendent to oversee the market. The geographic boundaries for the market at its inception were: "the roadway of Maxwell Street from the west line of South Jefferson Street to the east line of South Halsted Street..." which were "...set apart for market purposes on each and every day of the week..." This is a view of the Maxwell Street market just west of Jefferson Street, within its newly established boundaries. (Courtesy of the CHS, ICHi-31940, 1915.)

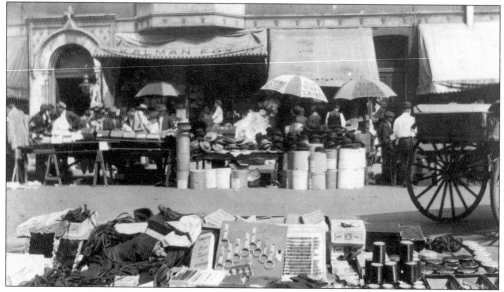

Kalman Fox emigrated from Russia in the 1880s and established this tailor supplies and trimmings store (now 606 W. Maxwell Street) on this same block. His sons continued working in the tailoring business in the Maxwell Street area and were known as the Fox Brothers. His grandson, Hal Fox, who was also a musician, is credited for creating the "zoot suit" that stylized much of the band entertainment of the 1940s. (Courtesy of the CHS, ICHi-31927, 1915.)

The Chicago Fire Department, organized in 1858, operated Engine 6 in three fire houses on Maxwell Street between the years 1864 and 1963. The first two fire houses were built at 514 W. Maxwell Street from which the steamer, "Little Giant" arrived first to the scene of the Great Chicago Fire of 1871 at nearby Jefferson and DeKoven Streets. The third fire house, built in 1913 at 559 W. Maxwell Street, was the last fire house built for the horse-drawn engine. Located just east of Jefferson Street, the Maxwell Street market was its "next door neighbor" throughout its years of service. (Courtesy of photographer Ken Little, 1956.)

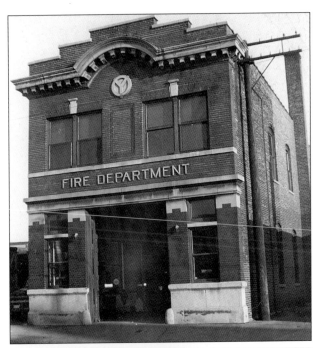

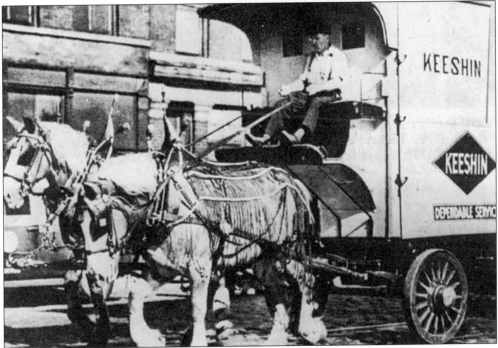

John Keeshin was a hard-driving entrepreneur born in the Maxwell Street area who attended Washburne School on nearby 14th Street and became a trucking magnate. As a teenager in 1916, he developed a horse and carriage delivery business called "Keeshin's Southwest Express." In 1920, he established "Dependable Service" with 25 trucks that grew to a transport service with 600 trucks by 1935. Keeshin Charter Services today is part of Coach U.S.A., Chicago. (Courtesy of Ira Berkow, from *Maxwell Street: Survival in a Bazaar, c.1920.*)

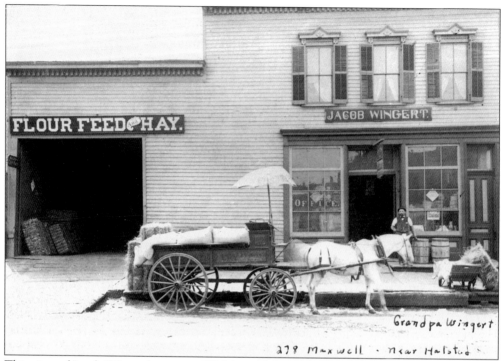

This view of Jacob Wingert's store at 278 Maxwell Street (today 735 W. Maxwell Street), just east of the Halsted Street intersection, is a rare view of Maxwell Street in the 19th century. Although the presence of a business here indicates commercial activity near the intersection of Halsted Street, Maxwell Street did not yet have the street activity and crowds that followed the 1912 city ordinance that created the market. (Courtesy of the CHS, ICHi-17659, c. 1880s.)

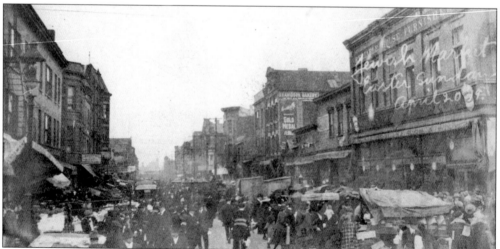

Pushcarts and wagons were initially used to barter wares in the newly established market, and they changed the complexion of Maxwell Street. This view east on Maxwell Street from its west boundary at Halsted Street shows the Wingert building (second from the foreground on the right), in the context of the street traffic that came to characterize Maxwell Street in the 20th century. (Courtesy of Special Collections, The University Library, University of Illinois at Chicago, Marcy-Newberry Center Records – M-N neg. 155, undated.)

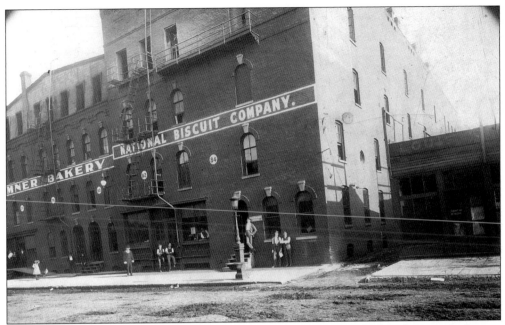

The National Biscuit Company (NABISCO), occupied a storage facility for wagons, horses, and feed on Maxwell Street (today 720-724 W. Maxwell Street) at the turn of the 20th century. Co-founded by David Bremner of the Bremner Bakery two blocks north on O'Brien Street (shown above), the NABISCO Bremner Plant extended one block in depth to 13th Street and another block in depth to Maxwell Street. Bremner, a Civil War hero, moved his bakery to O'Brien Street in 1872, after the Great Chicago Fire. In 1880, he patented the molding of bread in a spiral formation, thereby introducing the revolutionary brand—"Eureka." (Courtesy of Edward Bremner, Senior, and Dare Foods Limited, c. 1902.)

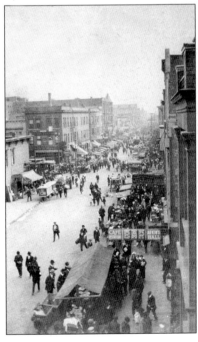

In 1916, another city ordinance extended the Maxwell Street market west to Sangamon Street. In this view east of Maxwell Street at the intersection of Halsted Street, stands are developing west within these new boundaries. Also faintly evident in this photo (mid-block, on the left) is the NABISCO facility, extending one block in depth. (Courtesy of Special Collections, The University Library, University of Illinois at Chicago, Marcy-Newberry Center Records – M-N neg. 159, undated.)

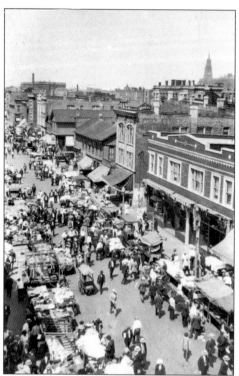

This view of the 800 and 900 blocks of Maxwell Street shows the westward extension of the market, c. 1918. The steeple of nearby Holy Family Church is on the horizon (on the right). (Courtesy of Special Collections, The University Library, University of Illinois at Chicago, Marcy-Newberry Center Records – M-N neg. 157, undated.)

A closer view of these street stands shows their frame construction and the coils of heavy rope that were strung to support tarps for the protection of the goods beneath. This view east from Halsted Street (below) shows vendors with merchandise displayed on the curb side stands, eagerly awaiting prospective shoppers. This environment set the stage for the street bartering that typified Maxwell Street. (Courtesy of the CHS, DN-0075248, by the *Chicago Daily News*, 1922.)

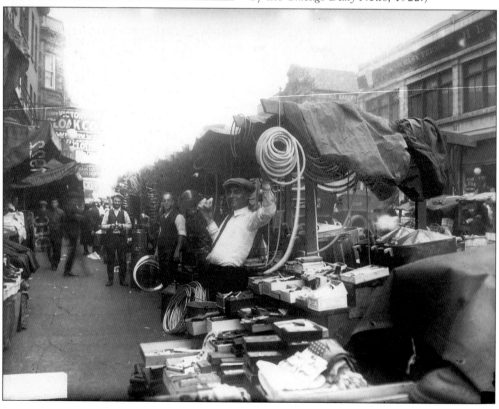

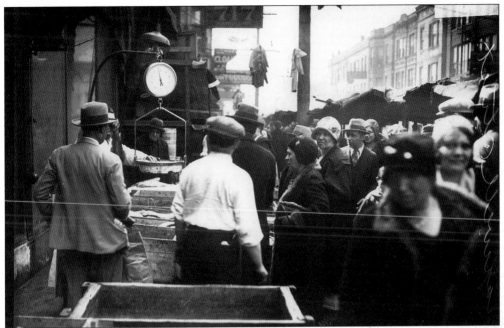

This view west along the 700 block of Maxwell Street features a popular fish market mid-block with a steady stream of attentive customers. In the background, garments hang suspended on store signs and street poles to advertise the clothing merchandise above the sidewalk crowds. (Courtesy of the CHS, DN-91669, by the *Chicago Daily News*, 1930.)

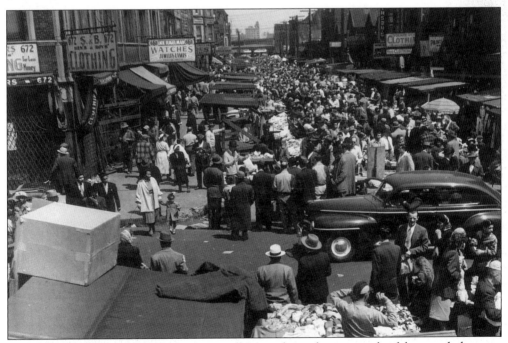

This view east along the 600 block of Maxwell Street shows the magnitude of the crowds drawn to the market and shops. Car traffic was nearly impossible on a Saturday or Sunday along Maxwell Street due to the dense pedestrian traffic. (Courtesy of the CHS, ICHi-32529, *c.* 1940s.)

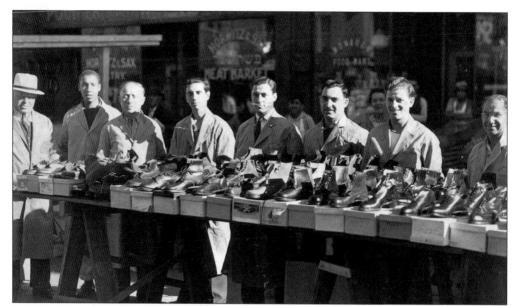

By 1931, a city ordinance established that "…no wagon, pushcart, truck or other vehicle and no stand used for the sale of goods…shall be permitted to…remain…after the hour of 7 o'clock p.m. of any day, nor before the hour of six o'clock a.m. of any day…" Here, vendors for Lerner's Shoes at 813 W. Maxwell Street set up for the day on tables that are easily taken down at the end of the day. (Courtesy of the CHS, ICHi-18536, 1937.)

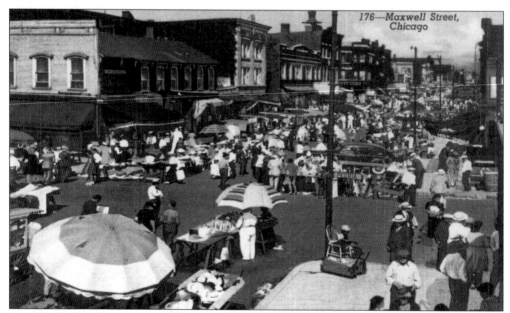

Toward the west end of the market, the 1931 ordinance was more apparent. This view east at Maxwell and Peoria Streets shows the temporary stands that were set-up and taken down each day, due to the later ordinance. Street stands nearer to Halsted Street became grandfathered-in as "permanent," and became the property of individual owners or shops. (Courtesy of the CHS, ICHi-35006, by Curt Teich & Company, Inc., 1941 and the Lake County Discovery Museum, Curt Teich Postcard Archives.)

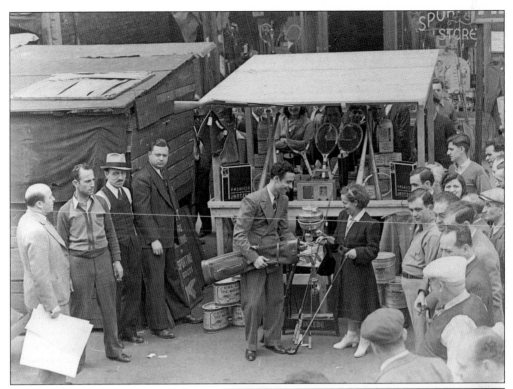

In 1939, the Maxwell Street Merchants Association (MSMA), comprised of 228 store owners and 89 pushcart proprietors, embarked on a campaign called the Maxwell Street Civic Improvement Project to standardize and improve the appearance of Maxwell Street. Above, in front of Kaye's Sports Goods at 716 W. Maxwell, a model stand is unveiled. (Courtesy of the CHS, ICHi-35178, 1939.)

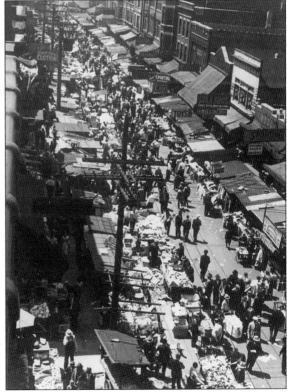

The face-lifting plan, which sought to streamline stands, pushcarts, and signs so that they were uniform in color and design, was never fully realized. However, this view west of the 700 block shows that some of the MSMA principles were implemented, evidenced by the orderly appearance of canopied storefronts and street stands. (Courtesy of the CHS, ICHi-34991, by Monty La Montaine, c. 1940s.)

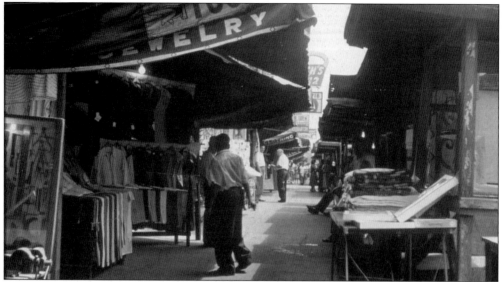

The canopied aisle of sidewalk between storefronts and street stands created a unique space for the shopper on Maxwell Street, as shown above in front of 728 W. Maxwell. A description by Ira Berkow reads, "The coolest place in summer is under the awnings that stretch from the stores to the permanent wooden stands at the curb; a kind of tunnel is created on the sidewalk, distinct from the openness of the 60' wide street." (Excerpt from *Maxwell Street: Survival in a Bazaar*.) (Courtesy of the CHS, ICHi-35413, 1955.)

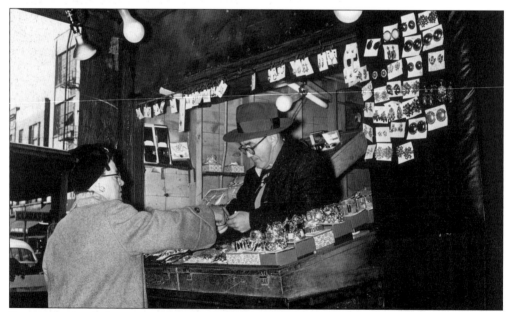

Permanent stands became enclosed and even acquired street addresses. This permanent stand was 10' x 10' x 7'6", and was designed so that its counter that served as a surface for business in the daytime could be drawn up and locked to secure the vendor's goods in the evening. They typically faced onto the sidewalk from the curbside of the street. Again, Ira Berkow recalled, "The sidewalks were so dark, in fact, that even in midday bare lights are strung up…" (Excerpt from *Maxwell Street: Survival in a Bazaar*.) (Courtesy of the CHS, ICHi-34426, 1955.)

The aisle of sidewalk between street stand and storefront also served as a captive space for the consumer. Along Maxwell Street, "pullers" were frequently employed in front of storefronts to literally "pull" the shopper into the store by the elbow or arm. (Courtesy of the CHS, ICHi-30763, c. 1955.)

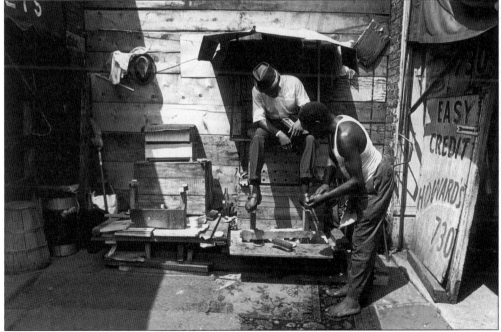

Every available space on Maxwell Street was utilized by enterprising individuals. Here, a shoe shine stand is set-up on the sidewalk against the boarded space between two neighboring buildings at 730 and 728 W. Maxwell Street. (Courtesy of the CHS, ICHi-35014, by James Newberry, 1967.)

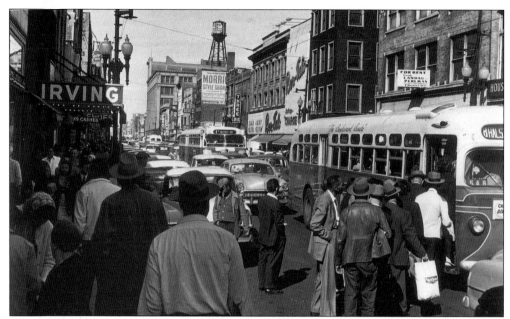

Along Halsted Street, the market was anchored by other types of commercial activity. Included in this view north from Maxwell Street along Halsted Street is the popular Irving Theatre on the left, a Woolworth's store built at 1301-03 S. Halsted in 1927 (in the right foreground), and the large, six-story 12th Street Store at the far intersection of Roosevelt Road. (Courtesy of the CHS, ICHi-34431, by Mildred Mead, 1955.)

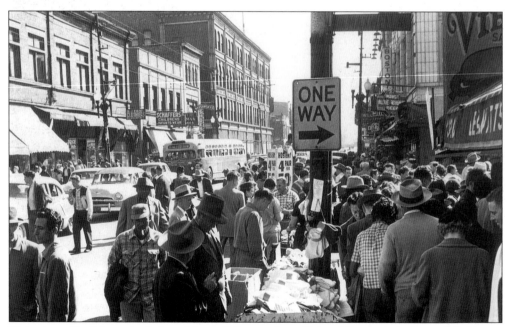

This view of buildings south from Maxwell Street along Halsted Street includes an S.S. Kresge store built in 1926 at 1335-37 S. Halsted, and the four-story L. Klein department store that occupied almost a half-block at 14th Street. Both the 12th Street Store (top photo) and the L. Klein department store predated the market. (Courtesy of the CHS, ICHi-34429, 1955.)

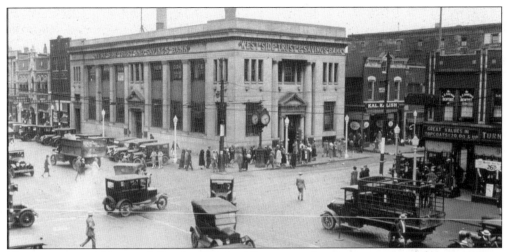

The intersection of Roosevelt Road and Halsted Street served as the gateway to the Maxwell Street market area. This view of the southeast corner of the intersection shows the West Side Trust and Savings Bank. A local bank was essential to the area merchants for the efficient operation of their businesses in the Maxwell-Halsted-Roosevelt commercial district. In the 1920s, this area rated third in volume of sales for the metropolitan area. (Courtesy of the CHS, DN-81631, 1926.)

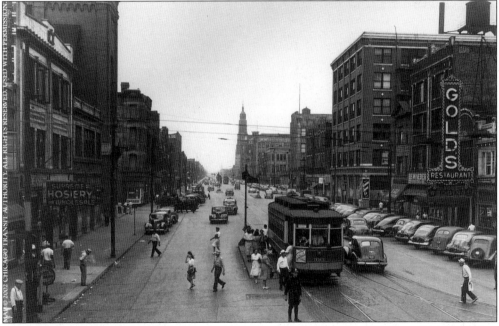

Gold's Restaurant (on the right) was a local landmark from the early 1920s until it was sold to the university for the Chicago Circle campus development on the north side of Roosevelt Road. Established by Meyer Gold just west of Halsted at 810-812 W. Roosevelt Road, the restaurant was known for its marvelous food and for the famous entertainers who dined there. They included George Jessel, Sophie Tucker, Al Jolson, and the Great Houdini. Upstairs, a popular banquet hall held the weddings and Bar Mitzvahs for the extended neighborhood, and it was also used for early band practices by Benny Goodman, who grew up in the neighborhood. (Courtesy of the Chicago Transit Authority, undated.)

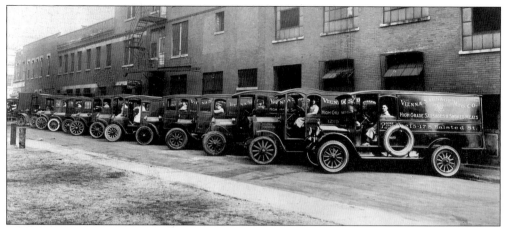

Vienna Sausage Manufacturing Company has a long history in the Maxwell Street area. Samuel Ladany and Emil Reichel, both immigrants from Austria-Hungary, opened a sausage shop at 1215 S. Halsted following their product's debut at the 1893 Columbian Exposition in Chicago. With a manufacturing facility in the rear, they sold sausage in the storefront and established Vienna Sausage Manufacturing Company. This photo shows their fleet of delivery trucks along the side of this building, where they operated until 1972. (Courtesy of Vienna Sausage Manufacturing Company, c. 1928.)

The all-beef sausage, nicknamed "the Vienna," became an enviable enterprise and the company was selling nation-wide by the 1920s. Throughout the market area, the company helped establish numerous stands selling Vienna Beef hot dogs and polish sausages by providing vendors with their product and the distinctive signs that advertised "Vienna Beef." With their manufacturing facility located just blocks away, the company ensured the freshness and availability of their product. (Courtesy of Vienna Sausage Manufacturing Company, c. 1960s.)

From the 1920s through the 1960s, virtually every street corner along Maxwell Street market had a hot dog stand like the one shown here, and these open-air food stands became characteristic of Maxwell Street itself. Flukey Drexler, who started the Chicago franchise "Flukey's," also started on Maxwell Street. He credited himself for the "Chicago Style Hot Dog," and advertised all fresh ingredients as "the works: tomatoes, lettuce, onions, peppers, mustard, relish and French fries." (Courtesy of the CHS, ICHi-34424, by Mildred Mead, 1955.)

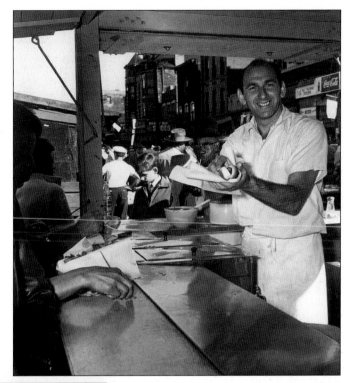

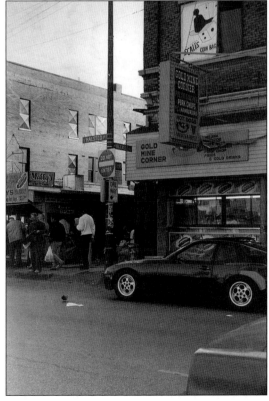

The "Goldmine Corner" was a popular stand serving Vienna Beef products on the southeast corner of Halsted and Maxwell Streets. "Matty's" occupied the permanent street stand in the background, on which signs advertised "Vienna Beef" and "Serving the Best for 42 years!" (Courtesy of photographer, Sheila Malkin, 1991.)

25

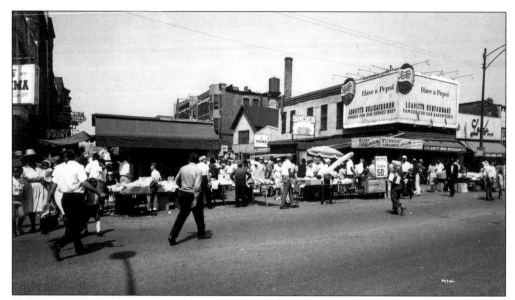

Other vestiges of the popular Halsted-Maxwell Street intersection included Leavitt's Delicatessen and Restaurant, which operated on the northwest corner from the 1940s into the 1960s. Known for their corned beef sandwiches, they also sold Vienna Beef products and had a bar inside. (Courtesy of the CHS, ICHi-34434, by Sigmund J. Osty, 1964.)

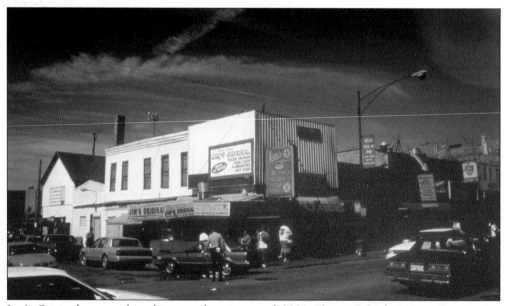

Jim's Original operated at this same location until 2001. "Jimmy" Stefanovic, a Roumanian immigrant, began this business outside the building at his aunt's street stand in 1939, and earned enough money to buy Leavitt's Delicatessen when it closed. The Stefanovic family has since operated the business 24 hours per day, 360 days per year. Maxwell Street is last remembered for the aroma of grilled onions and polish sausage from this stand. Today, Jim's Original is temporarily operating on Union and O'Brien Streets, where it continues its world famous reputation for Vienna red hots, pork chop sandwiches, and Maxwell Street Polish Sausages with sweet grilled onions. (Courtesy of photographer, Martin C. Tangora, 2000.)

Known for its kosher corned beef, Lyon's Delicatessen was located a half-block west of the Maxwell-Halsted intersection, where it operated from the 1930s through the 1960s. "Mama" Sarah Lyons continued provide pickled herring and gefilte fish for her son, who took over the business in the 1940s. (Courtesy of the CHS, DN-91668, 1930.)

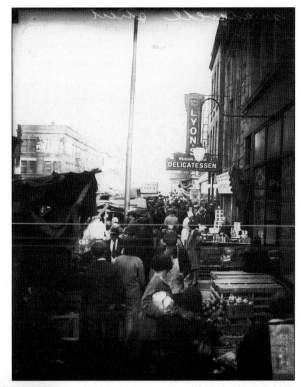

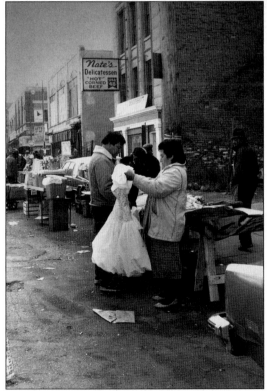

This same delicatessen became "Nate's Delicatessen" in 1972. When the Lyons's retired, they offered the business to Nate Duncan, an African American who had begun working for the family in the 1940s and spoke perfect Yiddish due to his years on Maxwell Street. (Courtesy of photographer, Sheila Malkind, 1981.)

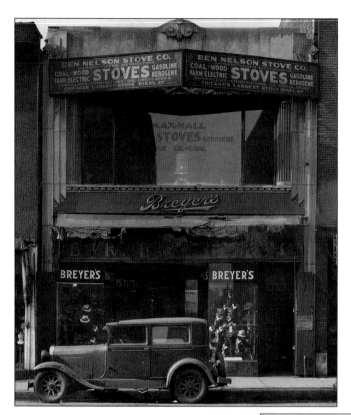

Other long-time businesses in the market area included "Breyer's," a hat business started by Adolph Breyer in 1895. In 1928, he built this store at 1304 S. Halsted. Breyer's hats, displayed in the ground level storefront windows, were sold through two generations of the family. By the late 1950s and into the 1970s, the store added shirts and slacks to its merchandise inventory. Although the building has since been rented to various businesses, it continued to bear the Breyer's name through to its closure in 2000. (Courtesy of Joan Breyer Gould, 1939.)

On Maxwell Street, David Klafter designed this storefront in 1909 for William Farber and Hymen Wittenberg, the latter of whom owned the Wittenberg Matzoh factory nearby on Jefferson Street. It became a long-standing meat market on the block and continued to bear the brick patterning of the 1909 storefront. A limestone element (partially visible at top of photo) bears the initials of the owners, "F & W." This was the early work of Klafter, who became a leading Jewish architect in Chicago. (Courtesy of Edward C. Shulz, 1954.)

From 1983 to 1992, the Commission on Chicago Landmarks conducted a survey to evaluate the architectural significance of buildings throughout Chicago. "Alan's" at 1212 S. Halsted, designed by Joseph Cohen in 1928, was one of five buildings in the immediate Maxwell Street area rated as "having architectural significance in the context of the community." It was also one of three clothing stores operated on Halsted Street by Paul Federman, who developed his business from a stand and store on Maxwell Street. (Courtesy of photographer, James Iska, 1993.)

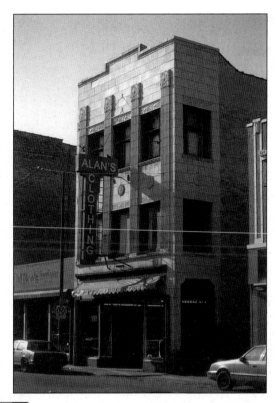

Another building included in this category of the Commission's survey was "Jerry's" at 1247 S. Halsted, designed in 1929 by Dubin and Eisenberg. This ornate terra cotta façade clearly illustrates the sophistication of locally prominent Jewish architectural firms contracted by property owners in the Maxwell Street area. Applied ornament on the façade bears the initials "EB" for the first owners, the Edelman Brothers. (Courtesy of photographer, James Iska, 1993.)

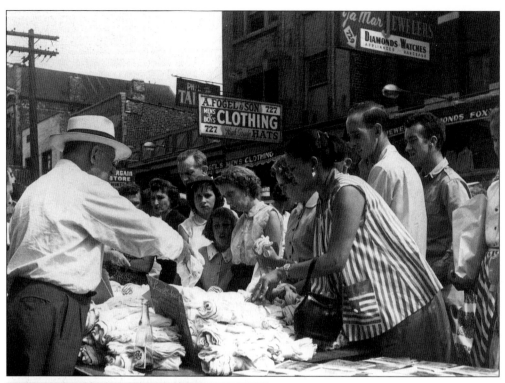

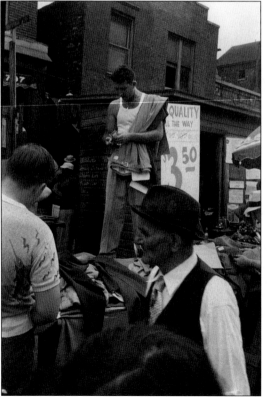

The 700 block of Maxwell Street was the clothing and tailoring center of the Maxwell Street market during most of the 20th century. In addition to clothing stores, tailor shops included Phil the Tailor at 727 W. Maxwell Street, which later became Paul and Bill's Tailor Shop at 719 W. Maxwell Street. "Ja Mar" at 729 W. Maxwell Street is also shown in the foreground of this photo. Known for expensive and exquisite jewelry, Ja Mar drew customers in limousines such as Elizabeth Taylor in the 1950s. (Courtesy of the CHS, ICHi-34455, 1954.)

Clothing was also "hawked" from street stands where shoppers could really get a bargain. This enterprising young man stands on his table in order to hawk his wares, from which he takes a momentary pause to count his money. In the 1950s, a "spot" to have a stand cost 17¢ on Maxwell Street. (Courtesy of Edward C. Shulz, 1954.)

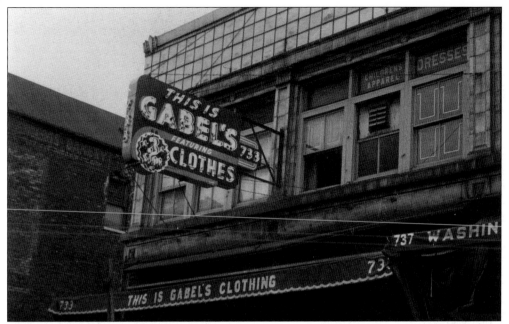

Gabel's at 733 W. Maxwell Street was the largest clothing store on the street in 1954, with 6,000 square feet of selling space. Its garments ranged from men's suits to women's furs. The store's glazed terra cotta façade is suggestive of early art deco and was designed by architect Merritt Moorehouse in 1920, who had studied in Paris before the style fully emerged in Chicago. (Courtesy of Edward C. Shulz, 1954.)

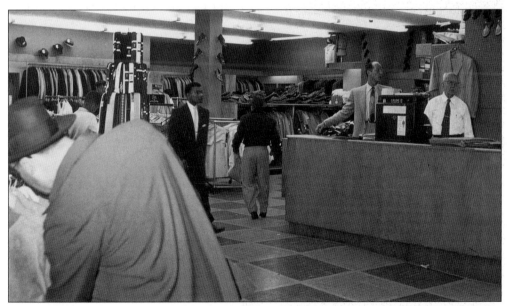

The interior of this store is that of "Smokey Joe's," which started on Maxwell Street in the 1940s and moved to Halsted Street in the 1950s. Smokey Joe's catered to the flashier, "in" crowd of the area through the 1960s, selling merchandise in loud colors that were on the crest of the fashion wave of the period. By the 1970s, Smokey Joe's was operating in two other locations, one of them on State Street. (Courtesy of the CHS, ICHi-34427, 1955.)

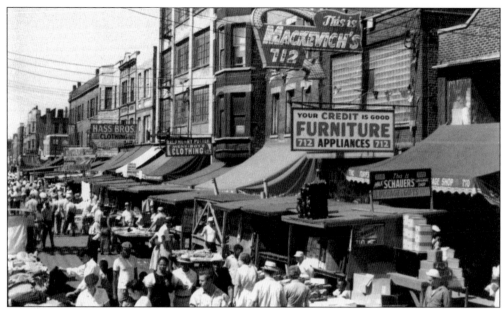

Mackevich's department store was the largest store selling general merchandise on Maxwell Street between the 1920s and 1970s. The store grew to triple its space on 13th Street (opposite side of the block), and was operated through three family generations, with entrances at 712 W. Maxwell Street and 711 W. 13th Street. Mackevich's also offered credit to their customers for major appliances. (Courtesy of Joan Breyer Gould, photo by the Breyer family, 1974.)

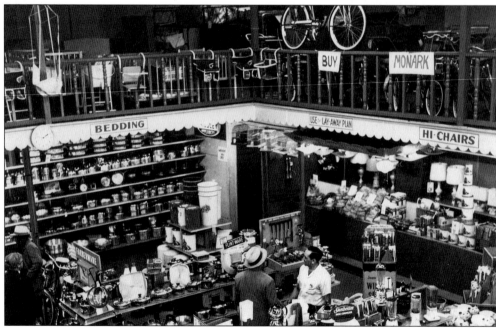

Inside Mackevich's, household merchandise ranged from furniture, clothing, appliances, to toys, including bicycles as seen suspended on the balcony. A large, self-service supermarket in the center of the store is claimed to be the first of its kind in the city. Mackevich's also operated the O'Brien Street Parking Lot for their customers. (Courtesy of CHS, ICHi 34452, 1955.)

Robinson's Department Store at 657 W. Maxwell Street occupied several storefronts that extended behind the store to Liberty Street. It was considered the second largest store on Maxwell Street by the 1950s, and was closed on all Jewish holidays. Started by Joseph Robinson in the 1920s, his philanthropic nature led him to bring Jewish refugees from the Holocaust to work at his store throughout the 1940s. He was active in many Jewish organizations and he was one of the founders of the Hebrew Parochial School in Chicago. Robinson's was the only store on the street that offered a money-back guarantee. (Courtesy of Edward C. Shulz, 1954.)

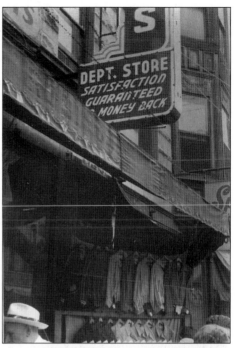

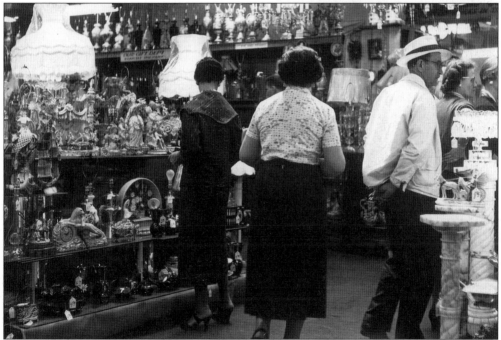

Inside, Robinson's was a department store, but it was especially known for its gift department and its imported and expensive items that ranged from lamps, rugs, Dresden china, tablecloths, and bedspreads, to the popular "mah jongg" Chinese game sets. Always closed on Friday evening for the observance of the Sabbath the following day, Robinson's would reopen after sundown Saturday night and stay open until midnight for its awaiting customers. (Courtesy of the CHS, ICHi-34453, by Margaret Mead, 1955.)

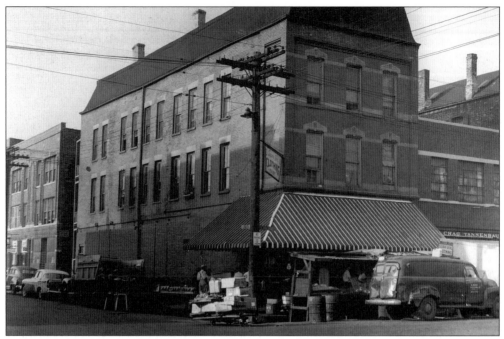

Other storefront businesses on the street catered to the clothing industry on the 700 block, such as Jack's Textile Fabrics, which was owned by Jack Karchmar, on the southwest corner of Maxwell and Union Streets. Karchmar earned the money to purchase this building from peddling yard goods across the street at a stand. Built in the 1880s, this large, brick tenement building had front and rear apartments on the second and third floors, a deep storefront, and a distinctive mansard-style roof. (Courtesy of the CHS, ICHi-25927, by Betty Hulett, 1957.)

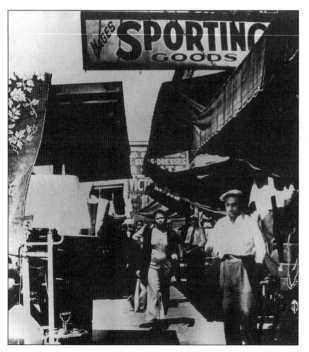

Other popular products on Maxwell Street included sporting goods. Mages Sporting Goods operated in several different storefronts on Maxwell Street in the 1920s through the 1940s and was operated by Henry Mages, Morrie Mages's father. Morrie worked in his father's store as a teenager. Although he never had a store on Maxwell Street, Morrie's ability to sell came from his Maxwell Street education. He sold baseball bats, mitts, and tennis rackets at street stands and out of his car, eventually opening his seven-story sporting goods empire at 620 N. LaSalle Street in upscale Chicago. (Courtesy of Lili Ann Mages Zisook, c. 1940.)

Many of the brick-faced storefronts were actually small, 19th-century frame cottages with gable roofs that had been given brick façades or had been hoisted onto brick store foundations near the turn of the century and given new brick façades. These modifications allowed property owners to maximize the commercial potential of their property on Maxwell Street. Here, the rear of a brick storefront at 721 W. Maxwell Street reveals the frame construction of a cottage that likely dates to the Civil War era. (Courtesy of photographer, Jeff Fletcher, 1993.)

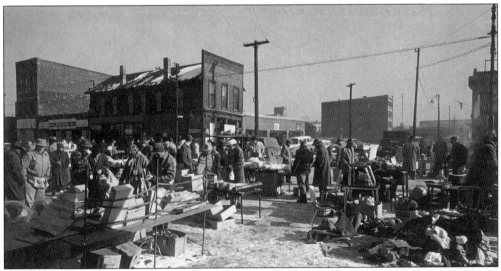

Shown amidst the land clearance that was begun in the market area in the late 1950s, the frame building that once housed Hattie Rubinsky's Grocery store at the turn of the century (as shown in the top photo, page 10) still stands on the northeast corner of the intersection of Jefferson and Maxwell Streets. The two-story frame cottage with a gable roof is shown behind a remodeled brick façade. (Courtesy of the CHS, ICHi-34477, by Clarence W. Hines, 1959.)

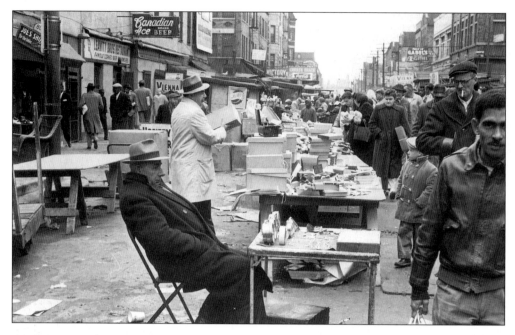

Up through the 1950s, the Maxwell Street market was strong and vital on both sides of Halsted Street, as shown above looking east on Maxwell Street and below looking west on Maxwell Street. Card tables were set out by proprietors at their designated "spot" in addition to the plywood stands provided by the city on sets of wooden horses. On Maxwell Street, prices were negotiable, and it is estimated that the market catered to 70,000 shoppers. (Courtesy of the CHS, ICHi-34470, top, and ICHi-34447, bottom, 1959.)

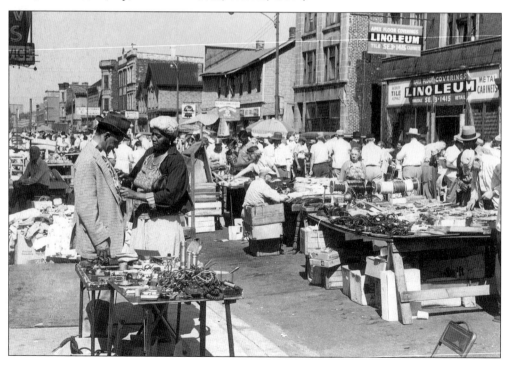

In the 1950s and 1960s, the Maxwell Street market gateway led into a V-shaped alley lined with additional shopping stalls that exited one block south on Liberty Street. The 600 block of Maxwell Street was known for the gypsies who lived there and told fortunes beneath the gateway entrance. (Courtesy of Edward C. Shulz, 1954.)

A woman proudly displays her purchase of a roll of carpet at the market on the 600 block of Maxwell Street. On her left in the background is the Maxwell Street market gateway. (Courtesy of photographer, Ronald Seymour, 1956.)

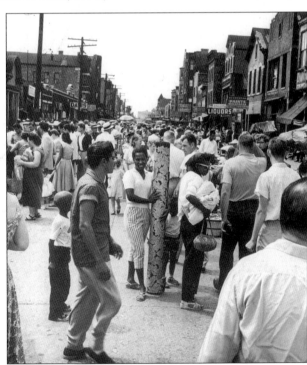

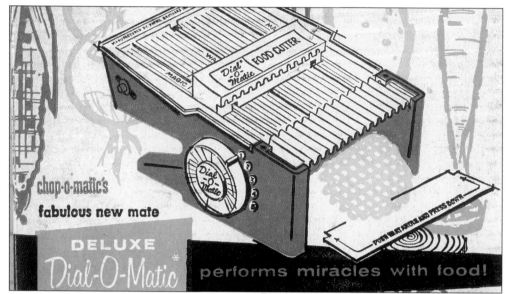

Pitchmen hawked food preparation gadgets like the 1958 Dial-O-Matic all along Maxwell Street and its market. This product was manufactured by former pitchmen Samuel and Raymond Popeil, who made a fortune by adapting their Maxwell Street sales techniques to television. Samuel's son is Ron Popeil, founder of Ronco, who still continues the tradition on late-night television. (Courtesy of Tim Samuelson, c. 1958.)

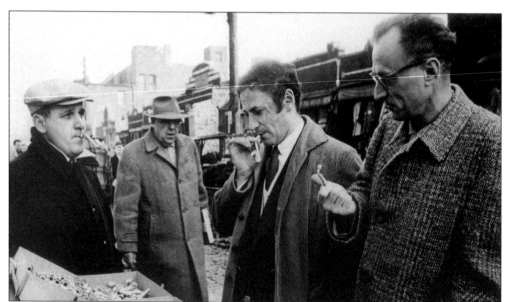

Nelson Algren, Chicago writer (right), and Marcel Marceau, mime (center), shop on Maxwell Street at a saxophone-kazoo stand. The market reminded Marceau of the Paris markets, and Algren visited often and felt a kinship to the people there. Simone de Beauvior, feminist writer and philosopher, was, for a time, a companion to Algren. She had said of Maxwell Street, "Superstitions, science, religion, food, physical and spiritual remedies, rags, silk, popcorn, guitars, radios—an extraordinary mix of all the civilizations and races …[at] a yard sale mixed with low-price luxury." (Courtesy of photographer Art Shay, c. 1957.)

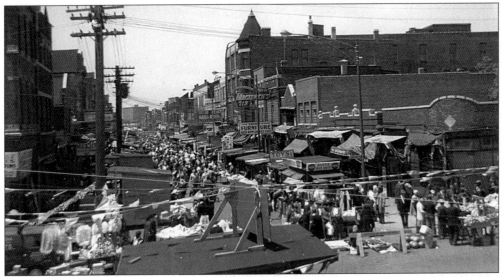

Following the completion of the south (Dan Ryan) expressway in the 1960s, the market was pushed west of Union Street. This photo was taken from the entrance ramp of the new freeway that rose over the remains of the 600 block of Maxwell Street, looking west at the remainder of the street and the market. (Courtesy of photographer, Ken Little, 1966.)

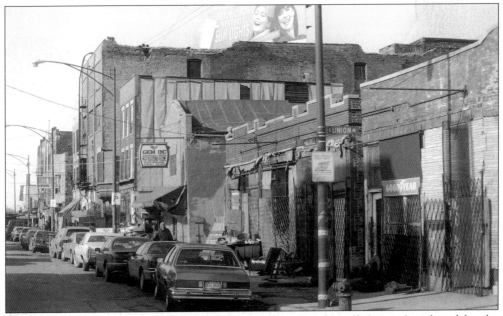

With the exception of the turreted building at 718 W. Maxwell Street (purchased by the university in 1992 and demolished in 1993) and the flat-roofed building at 708 W. Maxwell Street (both visible in top photo), the 700 block streetscape remained intact with businesses although the market had largely shifted west of Halsted Street. Above, the large manufacturing building (center) was appropriated by the university in 1987. The two shuttered buildings in the foreground were purchased by UIC in 1993, and demolished in 1995. The manufacturing building was mysteriously set afire on December 31, 1999, and burned throughout the first day of the new millennium. (Courtesy of the photographer, James Iska, 1994.)

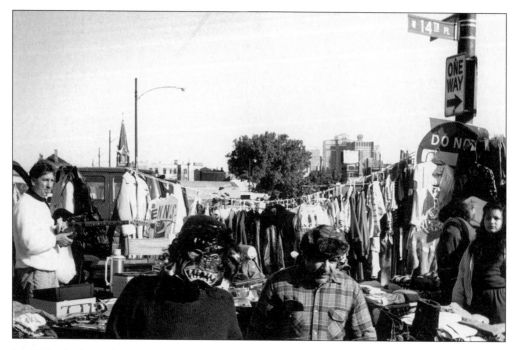

In 1963, the boundaries of the Maxwell Street market were changed to reflect the removal of its eastern section. It was now defined as "…the west line of Union Avenue to the east line of South Sangamon Street…" and also on "W. 14th Street and W. 14th Place from the west line of Halsted Street to the east line of S. Sangamon Street." Eventually, the market expanded onto all the adjoining side streets between Halsted and Morgan Streets, south of Roosevelt Road. The view of the market above is along W. 14th Street, and along S. Halsted Street, below. (Courtesy of the photographers Sheila Malkind, 1981, above, and James Iska, 1993, below.)

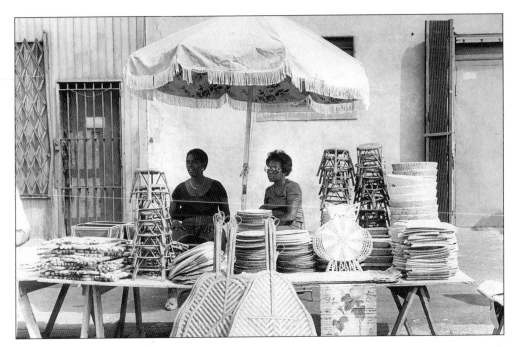

Merchandise and ethnicities changed with the geographic transition of the market in the late 20th century. Imported, hand-crafted wares are being sold by African-American women (above), and new radios and electronic speakers are being sold by an immigrant Korean woman (below). Still a flea market atmosphere, it is estimated that the market continued to attract 20,000 shoppers. (Courtesy of the photographer, Sheila Malkind, 1991.)

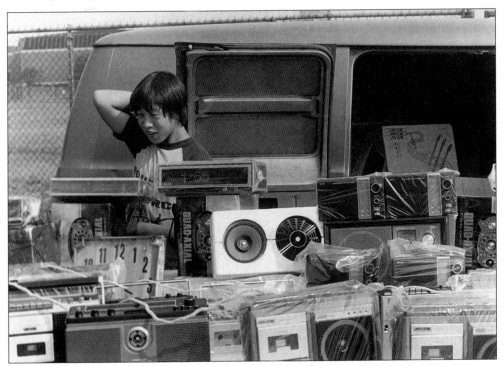

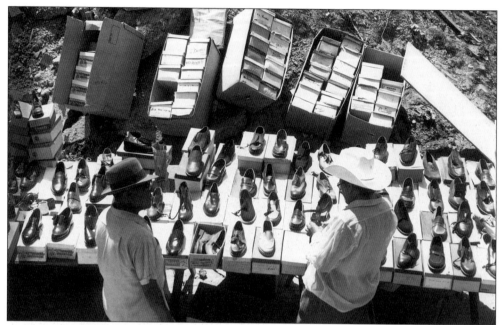

However, some things never change. The selling of shoes at the marketplace had historically been a common commodity. This vendor is spread out behind the table on the vacant land that was, by this time, coming to characterize the market due to the razing of the surrounding neighborhood. (Courtesy of the CHS, by Stephen Deutch, c. 1960s.)

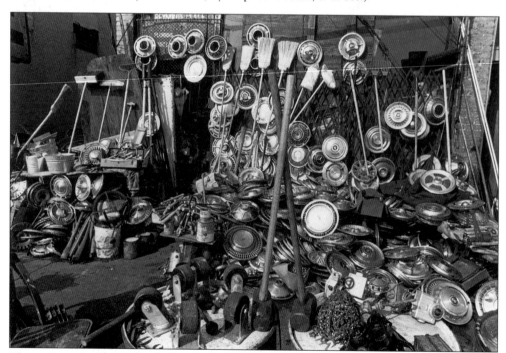

The market also acquired a reputation as a location to buy stolen goods. Hubcaps, presumably stolen, were profusely displayed along S. Halsted and Union Streets. (Courtesy of the CHS, ICHi-20332, by James Newberry, 1966.)

The busy intersection of Maxwell and Halsted Streets continued to be an exclusive location for certain street vendors. Above, Homer the "Sock Man," also known as the "Red Sox Baseball salesman," tends to his stand of cardboard boxes filled with white cotton socks on the northeast corner. (Courtesy of the CHS, G-1984-279, 1983.)

This street hawker is vending his wares to drivers and pedestrians alike on Maxwell Street, west of Halsted. The slowed traffic near the congested intersection created a captive audience for the sale of his street wares. (Courtesy of photographer, Sheila Malkind. 1981.)

43

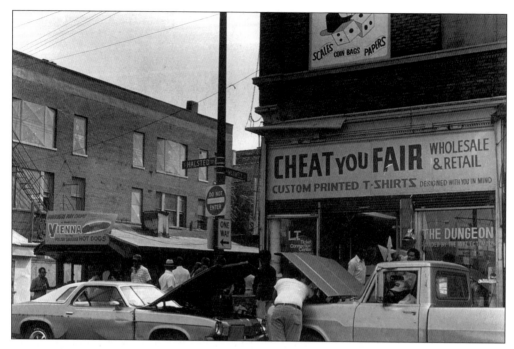

On the east side of the Halsted-Maxwell Street intersection, Vienna products still predominate as indicated by the sign on the permanent stand in the background. However, many food stands on Maxwell Street became infused with a new menu, which ranged from Mexican tacos to catfish dinners and chicken wings. Below, Johnny Dollar and his wife are shown at their food stand in front of 733 W. Maxwell Street. The neighborhood had long been a home for hand-painted signs and clever store names, such as "Cheat You Fair." (Courtesy of the photographers, Sheila Malkind, 1981, above, and the MSHPC, by Steven Balkin, 1998, below.)

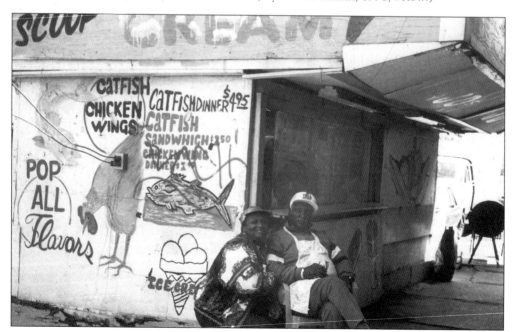

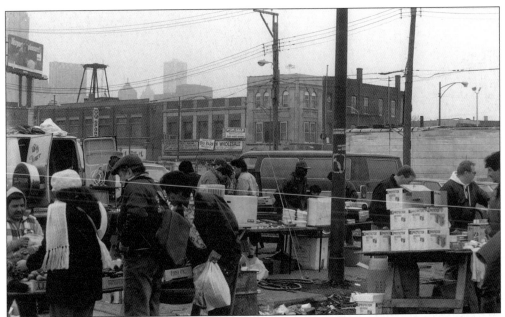

The market continued to operate on Sundays through all the seasons. This view east along W. 14th Street shows shoppers buying produce at stands in March. Vendors frequently purchased produce from nearby South Water market for resale at the Maxwell Street market. (Courtesy of photographer, James Iska, 1993.)

Through the early 1990s, the street wall of stores lining the east and west sides of Halsted Street south of the intersection at Roosevelt Road was intact and busy. It continued to serve as the "gateway" to the Maxwell Street market and offered merchandise at fixed prices that ranged from the traditionally sold men's clothing to the recent immigrant businesses that sold women's and children's clothing and notions. (Courtesy of photographer, James Iska, 1993.)

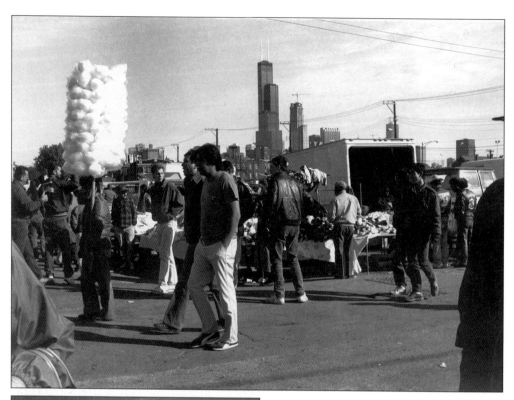

Maxwell Street was a thriving market and friendly public gathering place in the 1990s. Here, discount shoppers flock to the market for bargains and unique finds. The contemporary Chicago skyline serves as a backdrop to the city's urban phenomenon, which had been ongoing at this historic site for almost a century. (Courtesy of photographer, Sheila Malkind, 1991.)

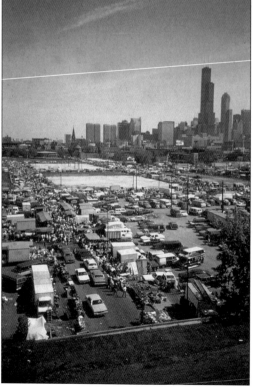

Nestled in the foreground of the cityscape, the Maxwell Street market saw its last day on Maxwell and its adjoining streets on August 28, 1994. Immediately following its closure by the city, the market was re-established along Canal Street several blocks to the east. (Courtesy of photographer, Lori Grove, 1994.)

Two

PORT OF ENTRY

FOR IMMIGRANTS & MIGRANTS

The Maxwell Street area became home for immigrants from around the world and for migrants from distant parts of America. Jews from Eastern Europe, African Americans from the south, and many others settled there, taking root and creating new livelihoods, art forms, and institutions. The Maxwell Street neighborhood was notoriously overcrowded for many years and went though a number of ethnic transitions, but it remained a place where all of the city's ethnicities met to exchange goods, foods, and customs.

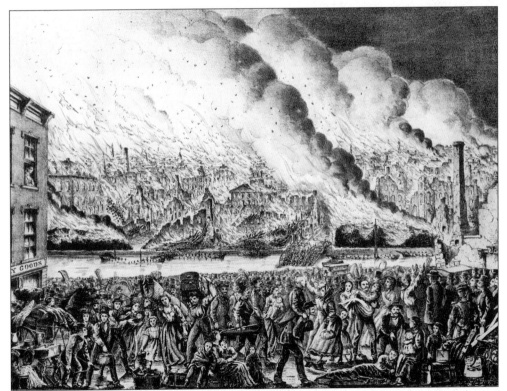

Refugees fled to the west side of the Chicago River during the Great Fire of 1871, which burned a huge swath of Chicago and left 100,000 people homeless. The fire started near the Maxwell Street neighborhood at Jefferson and DeKoven Streets in Mr. and Mrs. Patrick O'Leary's barn. Winds swept it northeast, and the Maxwell Street area was spared and became heavily populated after the fire. (Courtesy of the CHS, ICHi-02969.)

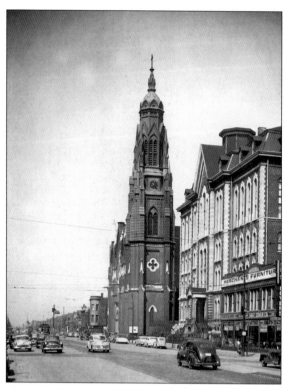

Irish, Germans, and Bohemians were some of the neighborhood's first residents as the opening of the Illinois and Michigan Canal brought activity to the area in the 1850s. Father Arnold Damen, a Dutch priest, attracted Irish Catholics to the area to build Holy Family Church in 1860, one of the largest Roman Catholic congregations in Chicago for many years. St. Ignatius College opened in 1870 next to Holy Family Church, and later became Loyola University. Today, the building houses the esteemed St. Ignatius High School. (Courtesy of the CHS, ICHi-24559, by J. Sherwin Murphy, 1951.)

A German Catholic parish, which formed in 1853, completed construction of the St. Francis of Assisi Church at Newberry Avenue and Roosevelt Road in 1875. The church has narrowly avoided destruction several times. It was gutted by a fire in 1904, was rebuilt, and then moved back 32 feet in 1917 for the widening of Roosevelt Road. In 1996, it was saved by its devoted Mexican-American parishioners, who occupied the church to prevent its demolition. (Courtesy of the CHS, ICHi-35113, by Anna Marie Sriver, 1969.)

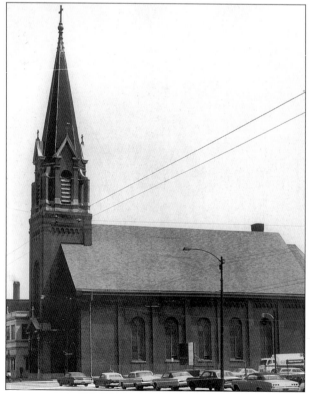

Theodor Ernst Buenger, a German immigrant, was the first teacher and choirmaster at the Immanuel Lutheran Church's school. A German congregation formed the church, originally located on the present site of St. Ignatius School. The Irish Catholics at Holy Family wanted the site and would often disturb services at the Lutheran church, which prompted them to retaliate. The church moved to Taylor and Sangamon Streets, then later to 1124 S. Ashland Avenue, and had one of the first integrated congregations in the city. Buenger is seen here with his son Theodor, c. 1864. (Courtesy of the Buenger family.)

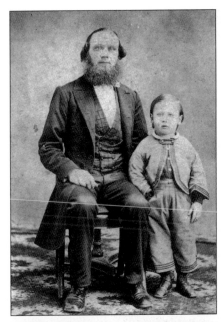

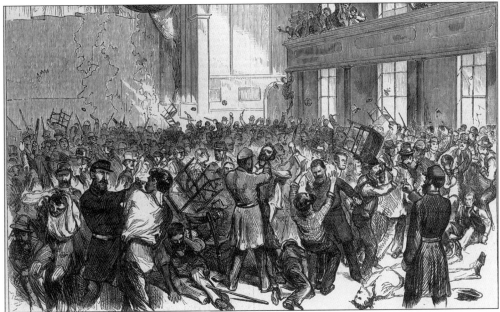

The Chicago German Furniture Workers Union was meeting with management to discuss wages, hours, and automation on the second floor of the West Side Turner Hall on July 26, 1877, at 12th (now Roosevelt Road) and Union Streets. With workers mobilizing in Chicago as the national railroad strike raged, the Illinois National Guard attacked workers outside, and Chicago Police heard about the meeting inside. Twenty armed policemen assaulted two hundred people at the peaceable meeting, injuring many and killing one man. This depiction by *Harper's Weekly* is an anti-labor portrayal, characterizing the workers as "roughs who never did an honest day's work" and "the lowest class of Poles and Bohemians." The event fueled the Battle of the Viaduct that took place the same afternoon nearby at 16th and Halsted Streets, where police killed 30 people. (Courtesy of the CHS, ICHi-14018, from *Harper's Weekly*, August 18, 1877.)

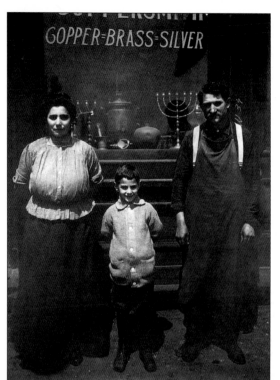

Jewish immigrants from Russia and Eastern Europe began arriving in Chicago in large numbers in the 1880s, spurred on by discrimination culminating in the violence of pogroms. Most settled in the Maxwell Street area and many made their livelihoods as self-employed peddlers or shopkeepers. Pictured here are Falick Novick, his wife, Tillie, and their son in front of their coppersmith shop on West 12th Street (Roosevelt Road), c. 1912. (Courtesy of the CHS, ICHi-15578.)

The Glassman & Brotin tobacco shop and cigar factory at 263 W. Maxwell Street (718 W. Maxwell today) displayed signs written with Hebrew characters. The signs read: "Smokers! If you want to please your lungs buy our Turkish Tobacco Cigarettes. We are the only ones whose tobaccos are [sold] at low profit. Come in and convince yourself." (Courtesy of the CHS, ICHi-20997 by Charles R. Clark, c. 1905.)

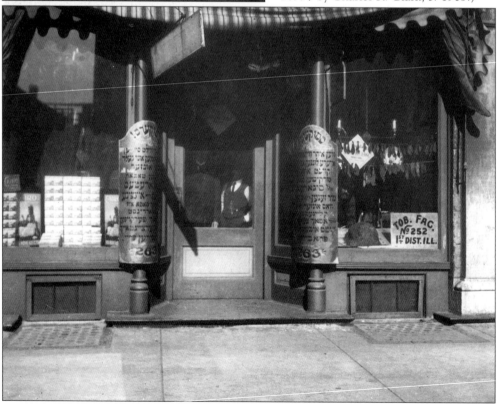

This mezuzah was found on the second floor doorway at 1210 S. Union Street, where early in the 20th century the three floors of the building served as a kosher butcher shop, a synagogue, and the residence of the rabbi who operated it all. The mezuzah was installed on doorways by Jewish residents and contains a small parchment with a hand-written excerpt from the Hebrew bible. The Jewish population was the largest and longest-standing in the Maxwell Street area between 1880 and 1920. (Courtesy of photographer, Ron Gordon, 1995.)

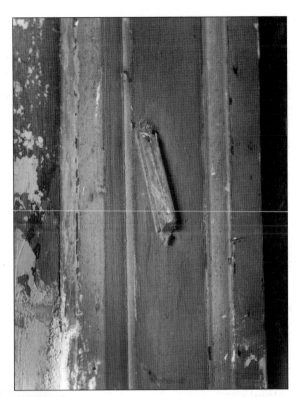

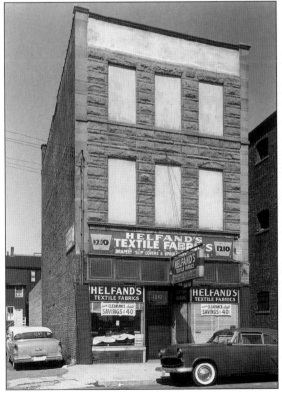

The same building at 1210 S. Union Street served as the base of operations for the Helfand family textile business in the 1940s. Started by Sam Helfand, a Jewish immigrant from Poland, the business was run by his sons and grandsons for over 35 years. Grandson Joel Helfand became the original clarinetist with the Maxwell Street Klezmer Band, which still performs today. (Courtesy of Joel Helfand, c. 1955.)

An 1891 survey showed 16,000 people living on a mile-long stretch of Maxwell Street. Sociologist Louis Wirth noted in 1911 that if the whole of Chicago were as densely populated as the Maxwell Street ghetto, the city would have thirty-two million people instead of two million. Sanitation and ventilation were problematic when the streets were muddy, garbage pickup was infrequent, and people shared overcrowded housing with few toilets. (Courtesy of the CHS, by Charles R. Clark, 1906.)

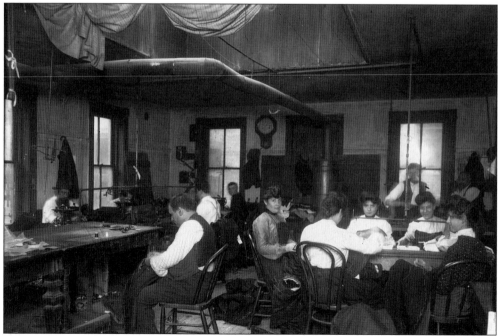

A sweatshop at 132 W. Maxwell Street (near Canal Street today) shows workers at tables and sewing machines in 1905. Men, women, and children often worked in unsafe and unhealthy conditions in tenement buildings, usually in the garment trades. (Courtesy of the CHS, DN-0002416 by the *Chicago Daily News*.)

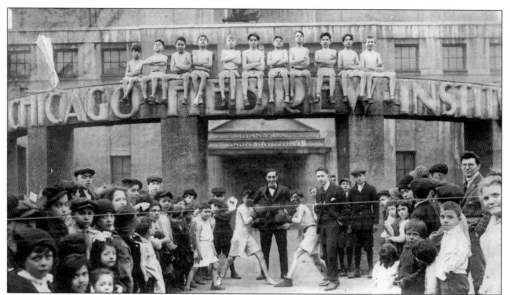

A number of social service institutions were organized to alleviate some of the conditions of crowded urban life, including the Chicago Hebrew Institute (CHI), which was founded in 1903 on Blue Island Avenue near 12th Street (now Roosevelt Road). This photo shows boxers and neighborhood children in front of the gymnasium at Taylor and Lytle Streets, c. 1915. The CHI was the forerunner of the Jewish Community Centers of Chicago. (Courtesy of the CHS, ICHi-17310.)

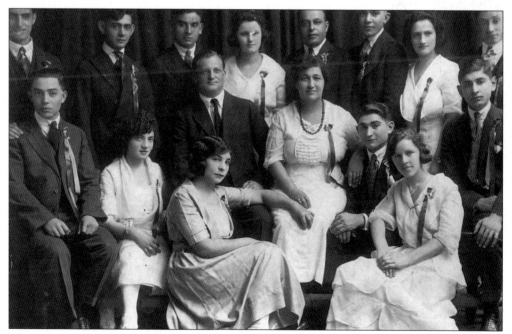

Many young people worked hard to lose the label "greenhorn"— a newcomer fresh from the old country—by taking language courses and adopting American styles of dress, such as this 1920 group of graduates from an English class at the Chicago Hebrew Institute. (Courtesy of the CHS, ICHi-17313.)

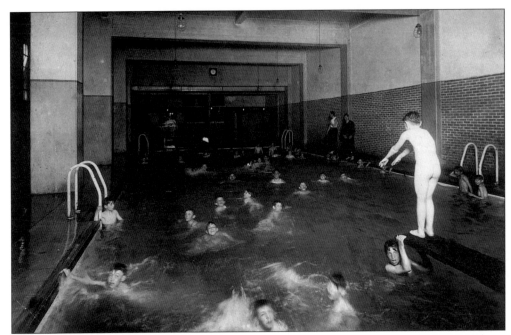

Sports and recreational activities, including swimming, were offered at the Chicago Hebrew Institute. The CHI moved in 1926 to the Lawndale neighborhood as the Jewish population moved west and was renamed the Jewish People's Institute. (Courtesy of the CHS, ICHi-17318, 1915.)

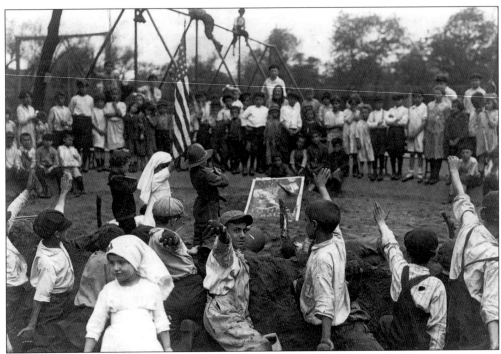

Patriotic pageants, such as this children's re-enactment of World War I at the Chicago Hebrew Institute, helped immigrant children identify with American society. (Courtesy of the CHS, ICHi-30115, undated.)

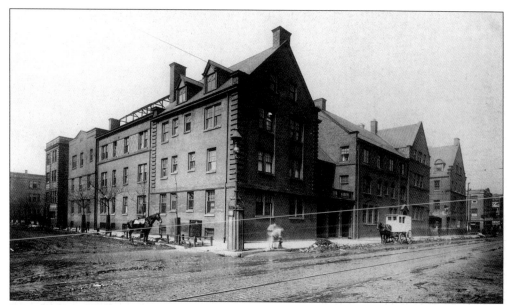

Jane Addams' Hull-House at 800 S. Halsted, a pioneer settlement house, was a place where many immigrants came for social activities and recreation. The nearby Italian, Greek, and Polish communities mixed here with the Jewish population and, later, with African-American and Mexican migrants. The settlement house was closed in 1963 for the building of the University of Illinois at Chicago, and the original Hull mansion opened as a museum and library. (Courtesy of the CHS, ICHi-17807 by Kaufmann & Fabry, c. 1912.)

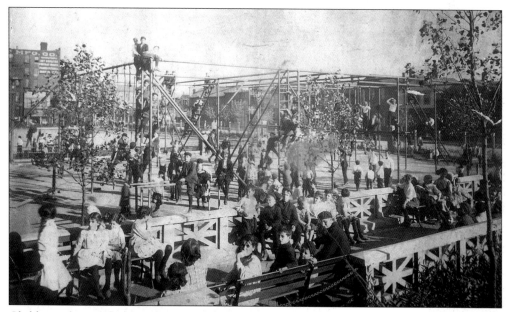

Children often played in alleys and streets, but many came to play in Stanford Park, which opened in 1910 at 14th Place and Union Street. Bathhouses were also important neighborhood institutions for all ethnic groups, as most homes did not have access to bathing facilities. Stanford Park had showers, and the nearby William Loeffler Public Bath House, at 1217 S. Union Street was free. (Courtesy of the CHS, ICHi-21181.)

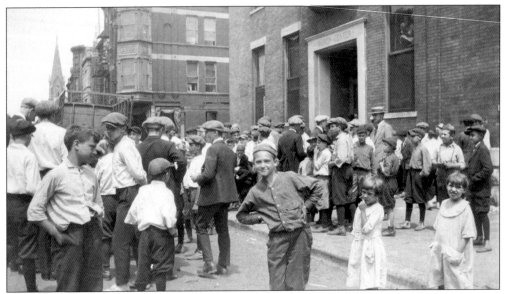

A group of children stand in front of the Marcy Center, which offered medical services to thousands of poor families every year from the southeast corner of Maxwell and Newberry Streets beginning in 1896. Other social service institutions included the West Side Dispensary for free medical care at Maxwell and Morgan Streets, the Maxwell Street Settlement on Maxwell east of Jefferson Street, and the Henry Booth Settlement House across from Stanford Park. (Courtesy of Marcy Newberry Center Records – M-N neg. # 88, Special Collections, the University Library, University of Illinois at Chicago.)

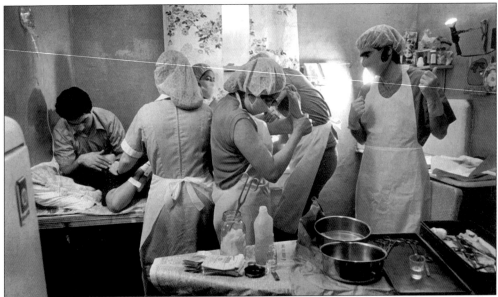

Doctors, nurses, a laboring mother, and father prepare for a home delivery through the Chicago Maternity Center in the early 1970s. This service was founded through the Maxwell Street Dispensary by Dr. Joseph Bolivar DeLee in 1895 and operated from 1336 S. Newberry Street by DeLee's successor, Dr. Beatrice Tucker, until 1973. (Courtesy of the Northwestern Memorial Hospital Archives, from the Chicago Maternity Center Collection, by Michael Mauney.)

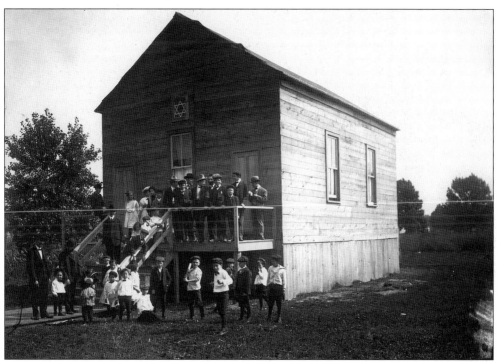

A number of schools served the Maxwell Street area, including this Hebrew School, probably Chicago Star of David, *c.* 1910. (Courtesy of the CHS, DN-2425 by the *Chicago Daily News*.)

Washburne Continuation School, an apprentice school at 655 W. 14th Street, had over 90 percent Jewish enrollment at the turn of the 20th century. (Courtesy of the CHS, ICHi-35143, 1928.)

Foster School was constructed in 1857 as Chicago's first masonry schoolhouse at the northwest corner of Union and O'Brien Streets. During the Civil War, it was the Union hospital for wounded from Chicago's Camp Douglas. It served as a grammar school until 1960, when it closed due to a declining population and new fire codes. Many police officers still recall the smells from the nearby Vienna sausage factory while the building served as the Police Academy and Library for the Chicago Police Department until 1975. The building was demolished in 1977. (Courtesy of the CHS, ICHi-35003 by John McCarthy.)

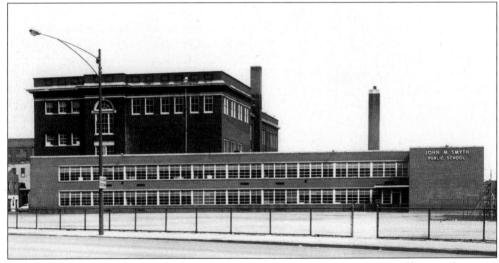

The John M. Smyth Elementary School at 1059 W. 13th Street had an enrollment of over 80 percent Jewish children at the turn of the 20th century. A century later, the school's population is 100 percent African American. (Courtesy of the CHS, ICHi-35070, by Tom H. Long, 1964.)

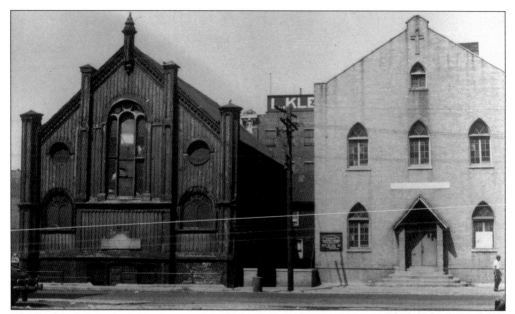

The Maxwell Street area had over 40 synagogues, which were important social institutions for the Jewish population and provided loans and aid for health, charity, and burial. These buildings on the northwest corner of Union and 14th Streets date from 1886 and were once a German Evangelical United Church and School. By 1914, both buildings were Jewish synagogues. The one on the left was the Congregation Paole Zedeck Anshe Sfard, and the building on the right, initially a wooden structure, was the First Roumanian Congregation. (Courtesy of Norman D. Schwartz, by Dr. Jack H. Sloan, c. 1945.)

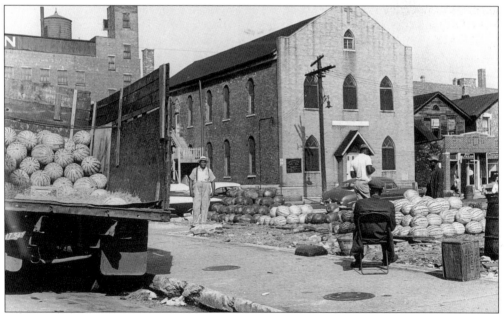

In 1935, the First Roumanian Congregation, referenced in the caption above, became the Gethsemane Missionary Baptist Church, established by an African American congregation. (Courtesy of the CHS, ICHi-23637, by M.J. Schmidt, 1957.)

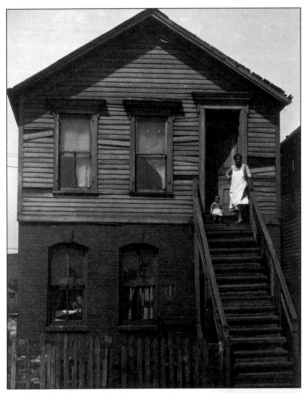

The "Great Migration" of African Americans to Chicago began in the 1910s as labor agents recruited southern blacks to fill jobs in the steel mills and stockyards in Chicago as immigrant entry was curtailed during WWI. The African American newspaper, the *Chicago Defender*, provided information about Chicago to southerners seeking better opportunities. Pictured here are a mother and child at their home near Maxwell Street, *c*. 1930-1950. (Courtesy of the CHS, ICHi-34997 by Monty LaMontaine.)

African Americans continued to move to Chicago in large numbers throughout the 1940s. A community known by residents as "Black Bottom," bounded by Jefferson on the east, 16th Street on the south, Union Avenue on the west and Roosevelt Road on the north, was 44 percent African American by 1930, but most residents were displaced by urban renewal in the 1950s. When the market moved in 1994, more than one third of the vendors were African American and thousands of black shoppers from nearby public housing and other neighborhoods frequented the market. (Courtesy of the CHS, ICHi-34996 by Monty LaMontaine, 1930-1950.)

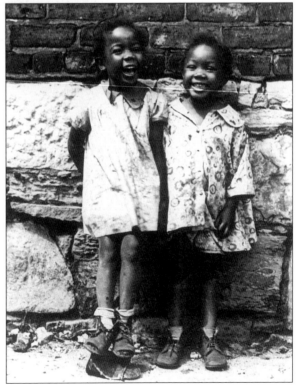

Stanford Park, one of the important institutions in the African American community, served as an after-school center for children and included a playground, athletics, a library, shower house, dances, and concerts. This page from a yearbook touted 591,000 participants for 1947-48 and heralded the contributions of Anna Walker, the dramatic instructor at Stanford and Union Parks and creator of the West Chicagoland Music Festival. (Courtesy of Bishop John D. Walker.)

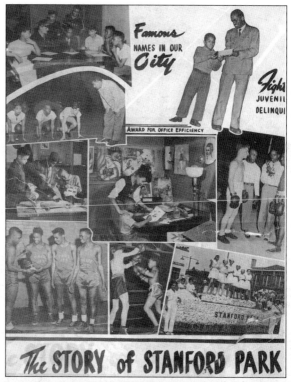

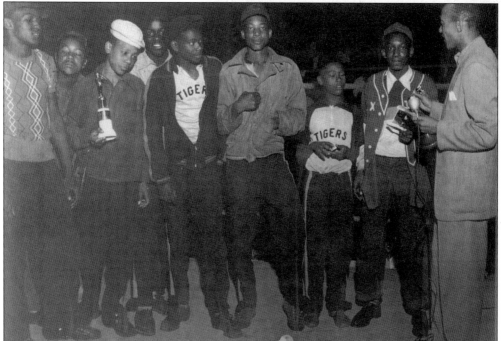

Jesse Owens, right, presents an award to the Stanford Park Tigers baseball team, c. 1946. Stanford Park was demolished for the Dan Ryan expressway in the late 1950s. (Courtesy of Bishop John D. Walker.)

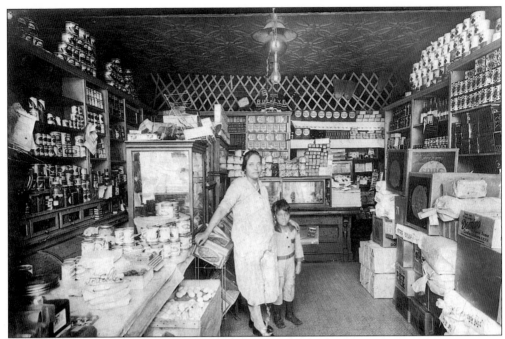

In the 1910s, Mexicans fleeing the Mexican Revolution came north to fill a shortage of workers in the United States during World War I, taking work in steel mills, factories, and on the railroads. Many settled on the Near West Side but were uprooted in the 1950s and early 1960s by urban renewal and the building of the University of Illinois at Chicago. Some moved southwest into the Pilsen neighborhood. Pictured here are Paula Hernandez Delgadillo and her son in her grocery store, "El Gardenia," at 1100 S. Peoria Street, 1921. (Courtesy of Tony and Lupe Hernandez.)

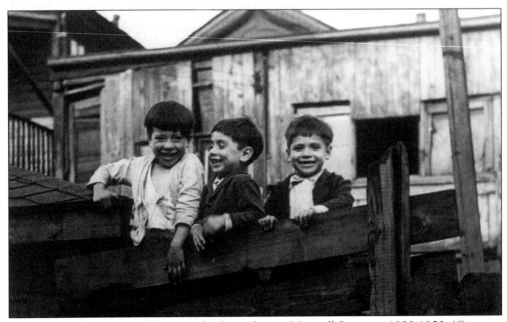

This photograph shows children on a back porch near Maxwell Street, c. 1930-1950. (Courtesy of the CHS, ICHi-34994 by Monty LaMontaine.)

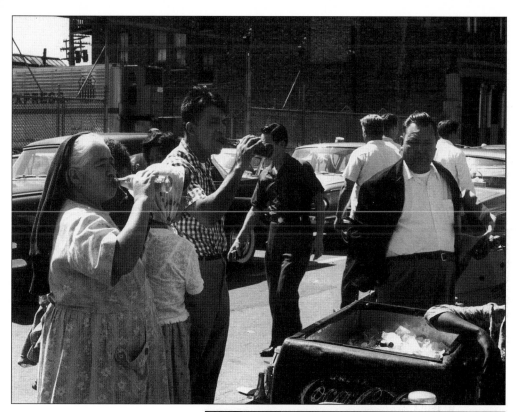

Drinking soda from a street vendor at the Maxwell Street Market, 1965. (Courtesy of photographer Jack Davis.)

A priest from St. Francis of Assisi talks with a parishioner and his daughter in front of the church at Roosevelt Road and Newberry Avenue, c. 1965. The church, originally built by a German parish, celebrated its first Spanish mass in 1925 and quickly became the heart of Chicago's Mexican community. The Archdiocese decided to close the church in 1994 but reversed the decision after parishioners moved into the church to prevent its demolition. (Courtesy of photographer Jack Davis.)

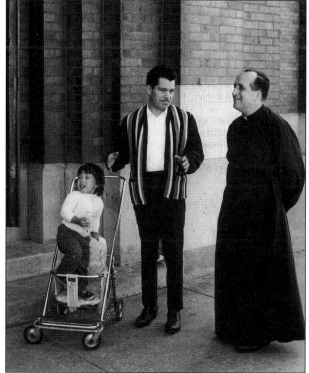

By the time the market moved to its new location in 1994, Latinos made up approximately one half of the vendors, and many of the Sunday market customers were also Latino. Pictured here is a Mexican stall on Maxwell Street between Union and Halsted Streets in 1972. (Courtesy of the CHS, ICHi-20326 by James Newberry.)

Gypsy, or Romany, people have long been a presence at the market, as the Maxwell Street neighborhood was an area of Gypsy settlement in Chicago. (Courtesy of the MSHPC, by Steven Balkin, c. 1995.)

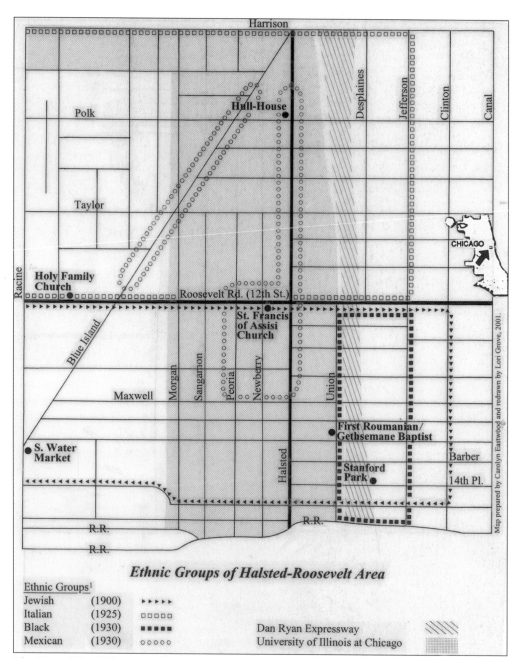

Ethnic Groups of Halsted-Roosevelt Area

Ethnic Groups[1]

Jewish	(1900)	▶▶▶▶▶
Italian	(1925)	▫▫▫▫▫
Black	(1930)	▪▪▪▪▪
Mexican	(1930)	○○○○○

Dan Ryan Expressway
University of Illinois at Chicago

Map prepared by Carolyn Eastwood and redrawn by Lori Grove, 2001.

The Near West Side was a diverse neighborhood in its entirety, even though groups generally chose social segregation. Exceptions were meeting places such as Jane Addams' Hull-House and the Maxwell Street market. It was often said of the market that "the only color that mattered was green." *Ethnic Groups of the Halsted-Roosevelt Area,* by Carolyn Eastwood. (Courtesy of the Lake Claremont Press, 2001.)

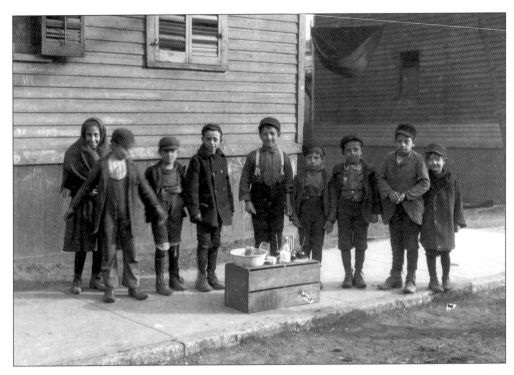

Over the years, many photographers have taken compelling candid shots of people in the Maxwell Street neighborhood, such as these images of young vendors in 1906 and these men on 14th Street in 1971. (Courtesy of the CHS, ICHi-31666, by Charles R. Clark and ICHi-35036 by James Newberry.)

Nathan Lerner photographed on Maxwell Street to improve his skills at composition for painting, capturing this man tying a package, c. 1936. (Courtesy of the CHS, ICHi-35043, by Nathan Lerner: Man with beard tying package, gelatin silver print. Copyright ©2002, Kiyoko Lerner. All rights reserved.)

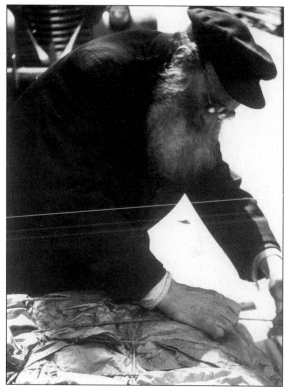

Men attended a memorial meeting for Republic Steel workers on Maxwell Street in 1937. On Memorial Day of 1937, 10 workers were fatally shot and 30 others wounded by police at a conflict over the strike at the Republic Steel plant at Green Bay Road and 117th Street. The U.S. Committee on Education and Labor investigated the incident and declared that the police actions were avoidable. (Courtesy of the CHS, ICHi-35045 by Nathan Lerner: Republic Steel Memorial meeting, gelatin silver print. Copyright ©2002, Kiyoko Lerner. All rights reserved.)

Artist Nathan Lerner stated that Maxwell Street was "a paradise for the artist who could see here ... the true intercourse between people, a feel for real objects, unpackaged, that life had scarred and made more beautiful by use." (Courtesy of the CHS, ICHi-35048, by Nathan Lerner: Window shopping, gelatin silver print, 1937. Copyright ©2002, Kiyoko Lerner. All rights reserved.)

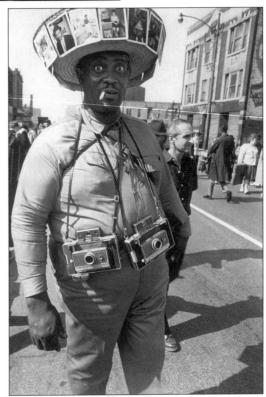

A photographer on Halsted Street, 1970. (Courtesy of the CHS, ICHi-35030 by James Newberry.)

Shown here is a young man at 744 W. Maxwell Street. (Courtesy of Mary Somogy, by Cornel Somogy, c. 1962-68.)

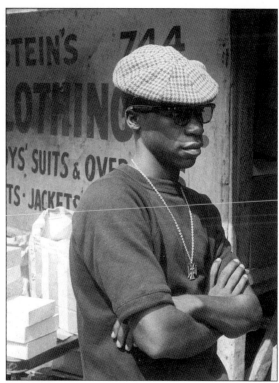

This young man is shown on a motorcycle. (Courtesy of Mary Somogy, by Cornel Somogy, c. 1962-68.)

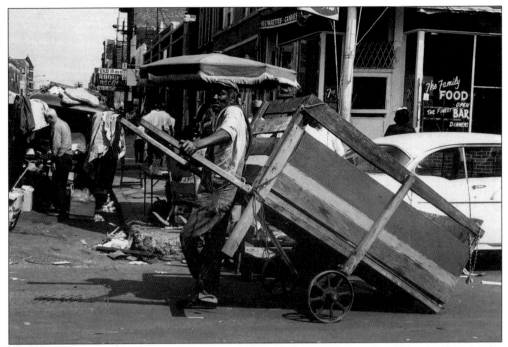

Man with a pushcart on Maxwell Street, c. 1965. Pushcarts were still used by vendors in the 1960s. (Courtesy of photographer Jack Davis.)

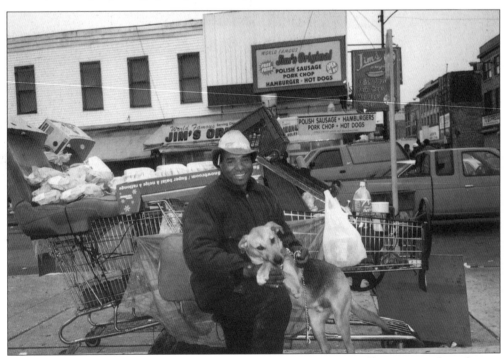

Pictured here is a West Side roving peddler using shopping carts to sell peanuts and sundries at the southwest corner of Maxwell and Halsted Streets. (Courtesy of the MSHPC, by Steven Balkin, 1998.)

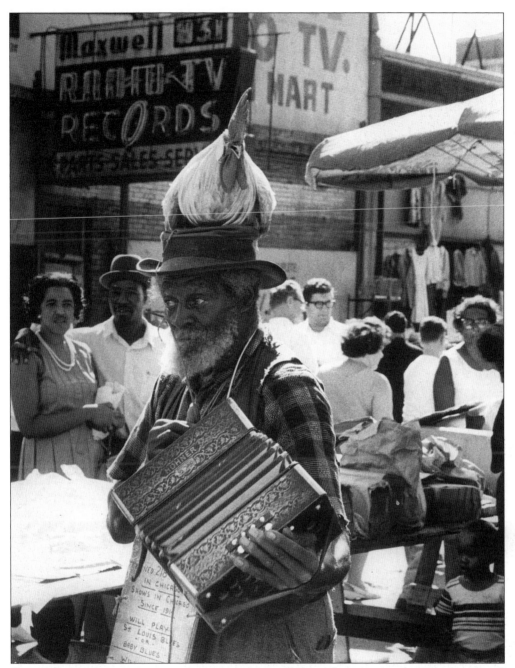

One of the best-known street entertainers on Maxwell Street for years was the "Chicken Man." Born in 1870, his name was Casey Jones, and he trained and performed with 218 chickens in Chicago. (Courtesy of photographer Jack Davis, c. 1965.)

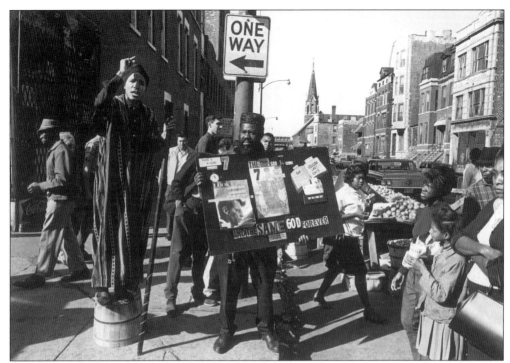

Along with its functions as a shopping and amusement center, Maxwell Street has also been called a religious center for all of the groups that have come to proselytize there, such as these Black Jews on Newberry Avenue east of Maxwell Street in 1967. (Courtesy of the CHS, ICHi-35011 by James Newberry.)

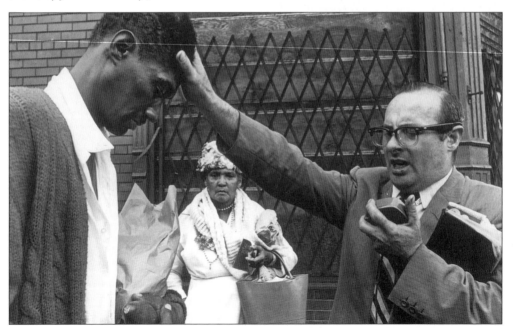

In this 1966 picture, a preacher prays for a shopper. (Courtesy of the CHS, ICHi-35010 by James Newberry.)

Shown here is a woman in tears after a Christian blessing by the same preacher in 1966. (Courtesy of the CHS, ICHi-35013 by James Newberry.)

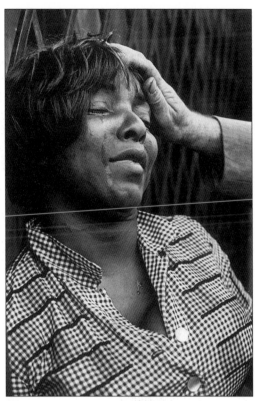

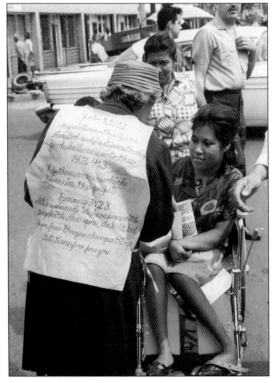

An evangelist speaks to a young woman in a wheelchair. (Courtesy of photographer Jack Davis, c. 1965.)

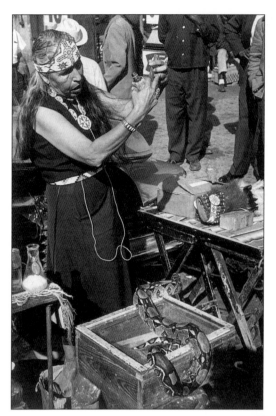

The market was always known for its attention-grabbing pitches and displays, such as this 1963 medicine show complete with a live snake, on Maxwell between Newberry and Halsted. (Courtesy of the CHS, ICHi-35032 by James Newberry.)

Reverend Cherokee styled herself as an Indian healer that could "bring in the Spirit of Release and control your every affair and dealings." (Courtesy of Mary Somogy, by Cornel Somogy, c. 1962-68.)

A girl from St. Francis of Assisi Church comes to Jim's Original hot dog stand to celebrate her "Quinceañera," or Sweet 15th birthday. (Courtesy of the MSHPC, by Steven Balkin, 2001.)

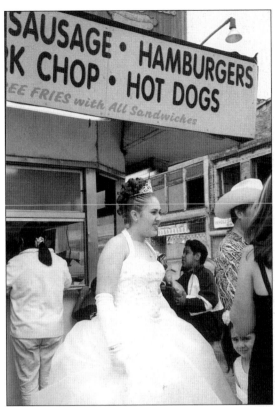

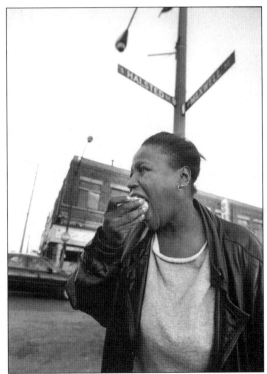

Pictured here is a woman eating a hot dog or Polish from a stand on Maxwell and Halsted Streets, 1999. (Courtesy of photographer Lee Landry.)

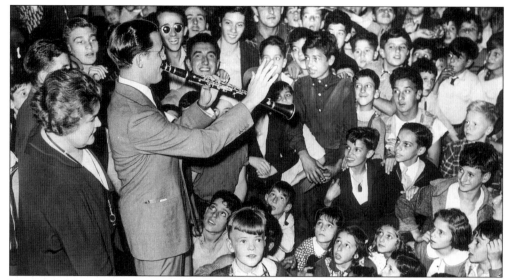

Many notable people grew up in the Maxwell Street neighborhood. Swing band leader Benny Goodman's father was a tailor and enrolled his children in a synagogue music program. Goodman played clarinet in the Hull-House band as a boy and returned there for a performance with Charlotte Carr and the Jitterbugs in 1938. Other artists from the neighborhood include actor Paul Muni (Muni Weisenfreund), who started in Yiddish theater and won an Academy Award for Best Actor for *The Story of Louis Pasteur* in 1936, and Harold Fox, aka Jimmy Dale, a musician and zoot suit maker at Fox Brothers Tailors. (Courtesy of the CHS, ICHi-18278 by the *Chicago Herald Examiner*.)

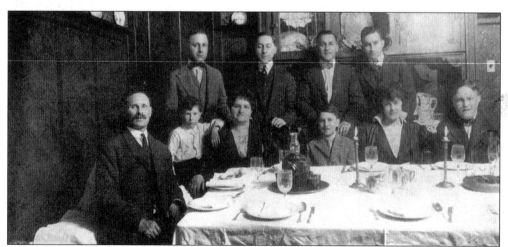

The Balaban family left Russia to escape service in the Czar's army and ran a grocery store at 1137 S. Jefferson. When Mrs. Gussie Balaban went with her son to the nickelodeon and saw people drop money in the box, she noted that customers paid up front, where their customers often shopped on credit. The family bought a theater at Kedzie and Roosevelt and went on to build the Balaban Katz theater chain, including such fine theaters as the Riviera and the Chicago Theater. When they sold most of their stock to Paramount Pictures, they had over 100 theaters, and Barney Balaban (1887-1971) became the influential president of Paramount for many years. Another media mogul from the area was William S. Paley, founder and chairman of CBS. Shown above are the Balabans at Passover dinner in 1942. (Courtesy of the CHS, ICHi-35142.)

Arthur Goldberg, Supreme Court Justice appointed by President Kennedy, is shown here on the stoop of his early Maxwell Street neighborhood home at the age of three. Arthur's father, Joseph Goldberg, broke a long line of family rabbis when he emigrated from Russia and settled on Maxwell Street to become a fruit and vegetable peddler. (Courtesy of Barbara and Duncan Goldberg, 1911.)

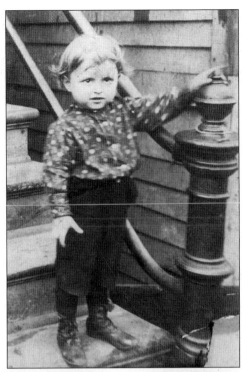

Colonel Jacob M. Arvey, the powerful chairman of the Cook County Democratic Committee, was instrumental in delivering Illinois, a critical state, in Harry Truman's unexpected victory over Thomas Dewey in the 1948 presidential election. Judge Henry Burman appears here between Arvey and President Truman in 1953. Arvey's father was a peddler, and his parents were immigrants from Russia. (Courtesy of the CHS, ICHi-35115, by the *Herald American*.)

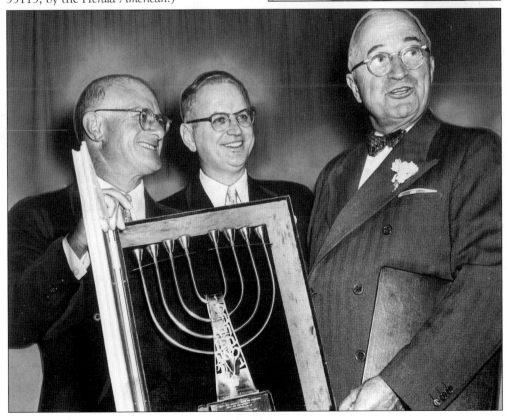

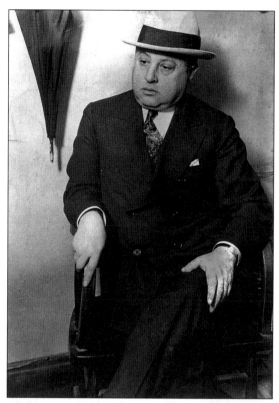

Jake "Greasy Thumb" Guzik was the business manager for gangster Al Capone's organization. He was born in Russia and lived in a number of residences as a youth, including one near the corner of Lytle and Taylor Streets. He was the mastermind of the Chicago race wire service that began in the 1930s, which controlled bookmaking information instantaneously and enabled the development of a national crime syndicate. (Courtesy of the CHS, DN-D-8761, by the *Chicago Daily News*, *c.* 1930.)

Barney Ross worked as a puller on Sundays at the Maxwell Street market, and his father was murdered in his grocery store on Jefferson near Maxwell in 1924. He was a Golden Gloves champion boxer and then became the world lightweight champion and junior welterweight champion in 1933. He was decorated for his heroism in World War II and successfully battled a narcotics habit that started when he was given morphine during his service. Two other fighters from the neighborhood were Jackie Fields and King Levinsky; the Levinsky family owned a fishmarket on Maxwell Street. (Courtesy of the CHS, ICHi-17405.)

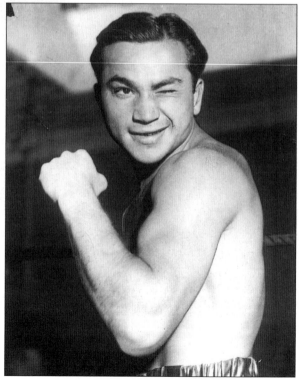

Three

THE PLACE TO HEAR
CHICAGO BLUES

As African-American southerners arrived in Chicago in the early and mid-20th century, they brought "down-home" blues styles from the Mississippi Delta and elsewhere. Musicians performed for tips and exposure to appreciative crowds on Maxwell Street. Some musicians began to plug amplifiers for electric guitars into store outlets, and country blues evolved into Chicago electrified blues on Maxwell Street.

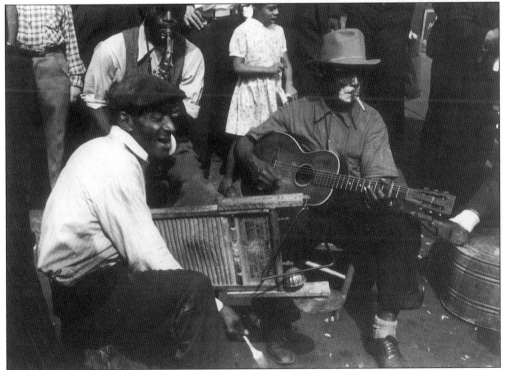

Country blues instruments, such as washboards and brown jugs, were common sights in 1930s blues ensembles on Maxwell Street. (Courtesy of the CHS, ICHi-35042, by Nathan Lerner: Washboard player, gelatin silver print, 1936. Copyright ©2002, Kiyoko Lerner. All rights reserved.)

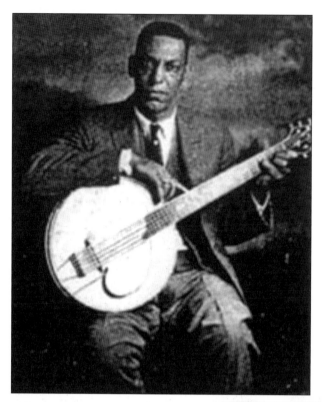

"Papa" Charlie Jackson worked in minstrel and medicine shows and then came to Chicago and worked for tips, singing and playing banjo on Maxwell Street through the 1920s and 1930s. His song "Maxwell Street Blues," recorded for Paramount Records in 1925, includes the lines "Lord, I'm talkin' about the wagons, talkin' 'bout the pushcarts too, Lord I'm talkin' about the wagons, talkin' 'bout the pushcarts too, 'Cause Maxwell Street's so crowded, on a Sunday you can hardly pass through."

Big Bill Broonzy farmed and played the fiddle in the South, served in World War I, and then moved to Chicago where he learned to play blues guitar under the guidance of Papa Charlie Jackson. He was a major country blues singer in Chicago in the 1930s and 1940s and helped introduce Europeans to the blues by touring there in the 1950s.

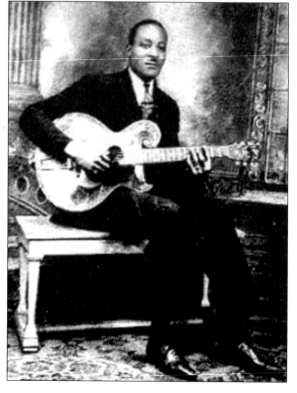

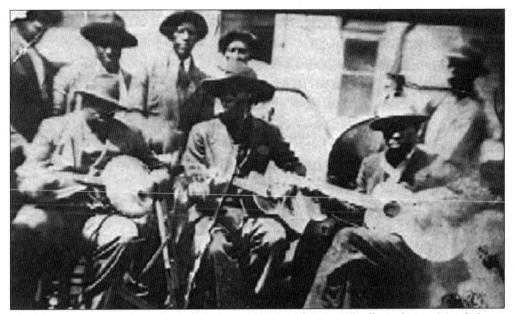

The Moody Jones Band on Maxwell Street, *c.* 1945, with James Kindle on banjo, Moody Jones on guitar, center, John Henry on guitar, right, and Ed Newman on bass, back right. Moody Jones was born in Arkansas and came to Chicago in 1939. Moody's first cousin was Floyd Jones, another blues musician that played Maxwell Street. (Courtesy of *Chicago Blues*.)

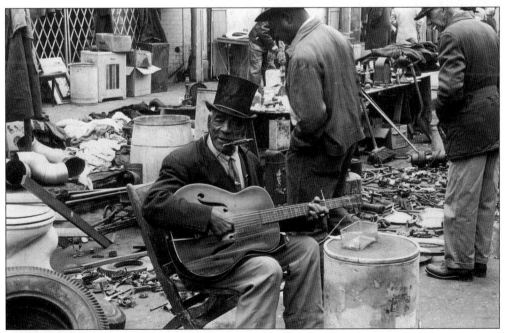

Johnny "Daddy Stovepipe" Watson, a one-man band with guitar, harmonica, kazoo, and jug, plays at the Maxwell Street Market in 1959. Born in 1867, he was one of the oldest blues musicians to record commercially in the 1920s. He recorded with his wife "Mississippi Sarah" as well, and when she died in 1937, he became a regular at the market, often singing Christian music, until his death in 1963. (Courtesy of the CHS, ICHi-12834, by Clarence Hines, 1959.)

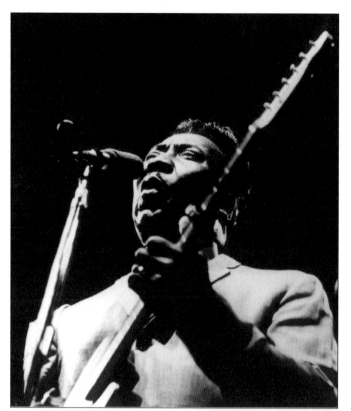

Muddy Waters played at Clarksdale, Mississippi, parties and juke joints, then moved to Chicago in 1943, where he played at rent parties in the neighborhood and made appearances at music shops on Maxwell Street to promote his records. His amplified style of playing and his innovations in the blues band lineup have become synonymous with the Chicago Blues sound. He has influenced many artists, from Jimi Hendrix to the Rolling Stones, who took their name from one of his songs. (Courtesy of photographer Ray Flerlage, 1965.)

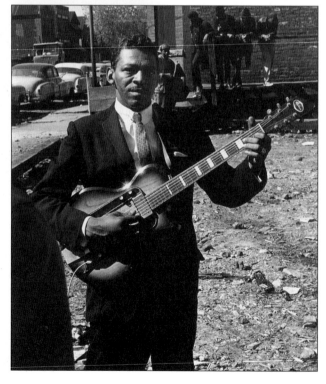

"Little Walter" Jacobs, considered the greatest blues harmonica player, is seen here on Maxwell Street playing the guitar to avoid trouble with the musicians' union. He came to Chicago in 1945 and continued to play on Maxwell Street for the rest of his life, even after he became a major recording star and an innovator of amplified harmonica stylings. (Courtesy of photographer Ray Flerlage, 1963.)

The only record company based on Maxwell Street, Bernard Abrams' Ora-Nelle label released Little Walter Jacobs' first record in 1947. Othum Brown, another Maxwell Street regular, is featured on guitar on this single, "I Just Keep Loving Her."

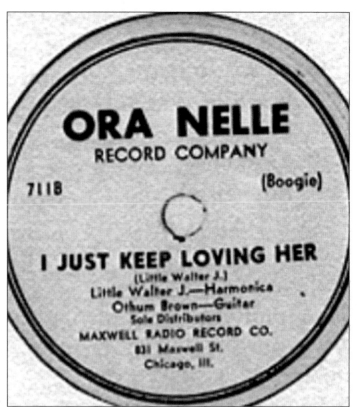

Maxwell Radio Record Company, at 831 W. Maxwell Street, the location of the Ora-Nelle label and owned by Bernard Abrams, was located across the street from the record shop below. Store proprietors, like Abrams, allowed musicians to plug in amplifiers for street performances. (Courtesy of the CHS, ICHi-19407, by Carol Rice, 1953.)

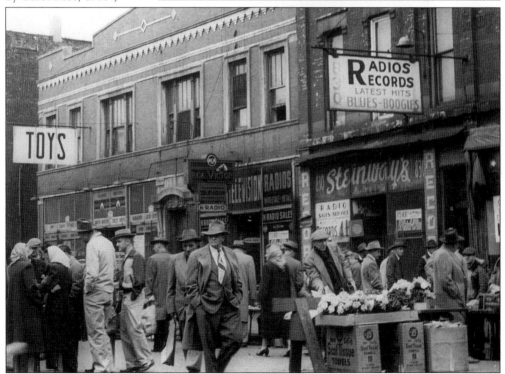

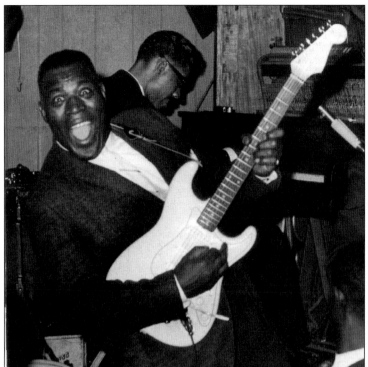

Howlin' Wolf, whose real name was Chester Burnett, came to Chicago in 1952 after farming, serving in World War II, and touring the South as a musician. He was known for his fierce singing style, his signature "howl," and his commanding stage presence. (Courtesy of photographer Ray Flerlage, 1964.)

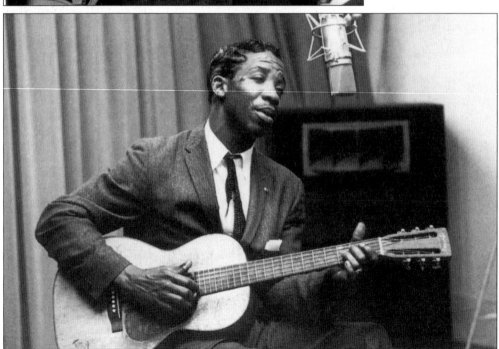

"Maxwell Street" Jimmy Davis, known also as "Jewtown Jimmy," had an emotional style of singing and guitar playing. He played Maxwell Street from the mid-1950s into the 1970s and owned and operated the Knotty Pine Grill on Maxwell Street, often playing out front to attract customers. (Courtesy of photographer Ray Flerlage, 1965.)

Robert Nighthawk, like many of his contemporaries, did farm work, hoboed, and played in juke joints before coming north in the 1930s. This album, "Live on Maxwell Street – 1964" by Rounder Records, is unique as it was recorded on the street. He was known for the sad quality of his guitar slide and for his deep brooding vocals.

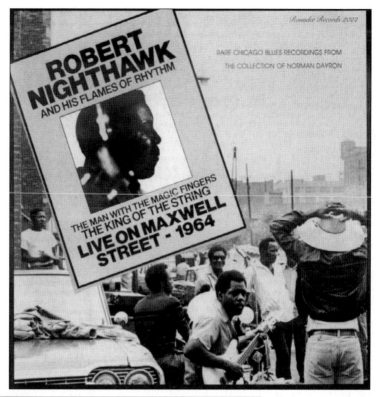

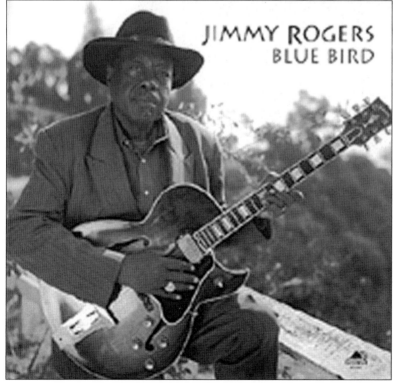

Jimmy Rogers has been recognized for his songwriting and classic guitar work and was one of the three founders of Muddy Water's first band. This 1994 recording "Blue Bird," by Analogue Productions, features another Maxwell Street regular, Carey Bell, on harmonica.

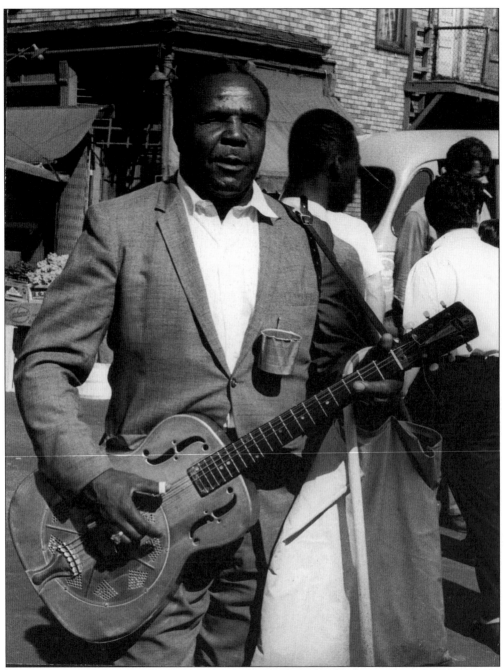

"Blind" Arvella Gray was a farmer, laborer, and roustabout for the Ringling Brothers circus. He lost his eyesight and two fingers in a shotgun accident in 1930. He returned to Chicago, learned guitar, and worked for tips on Maxwell Street from the early 1930s through the 1970s. Note his National steel guitar and the paper cup pinned to his lapel. (Courtesy of photographer Jack Davis, *c.* 1965.)

Jim Brewer was blinded in his youth, and his parents encouraged him to learn music—his father favored the blues and his mother favored gospel music. He came to Chicago in 1940 and played Maxwell Street off and on for over 40 years. In the 1960s and 1970s, he played with a gospel group. (Courtesy of photographer Ray Flerlage, 1961.)

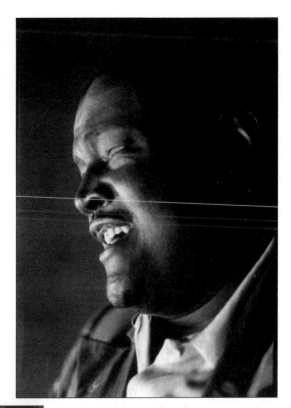

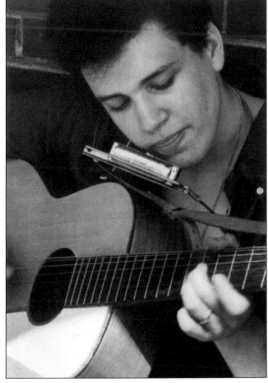

Michael Bloomfield was born in Chicago and, in 1957, began visiting clubs on Chicago's South Side. He played with Robert Nighthawk on Maxwell Street in the early 1960s and, in 1965, joined the Paul Butterfield Blues Band and performed with Bob Dylan.

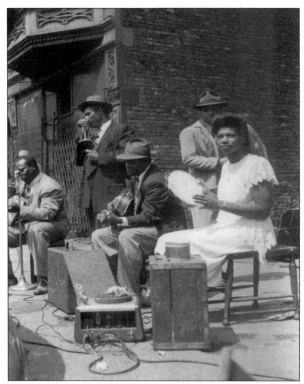

Religious music was as common as blues at the Maxwell Street Market, as shown by this gospel group. The woman is Carrie Robinson, who started singing blues and gospel when she was 14 years old. (Courtesy of the Nice Card Company, c. 1940s.)

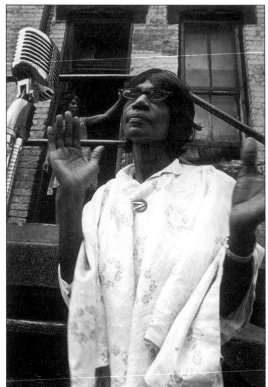

Carrie Robinson, pictured above, here sings gospel music on Newberry Street a few decades later. (Courtesy of the CHS, ICHi-35035, by James Newberry, 1971.)

This photograph shows a woman in white playing tambourine on Peoria Street east of Maxwell Street in 1966. (Courtesy of the CHS, ICHi-35015 by James Newberry.)

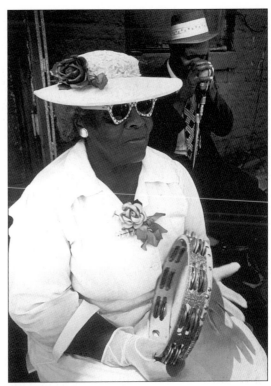

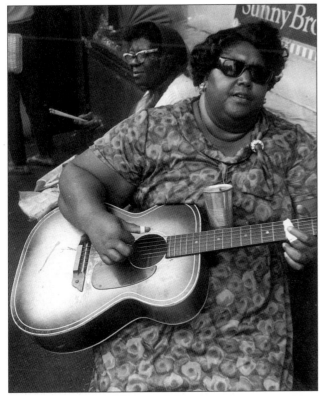

Shown at left is an unidentified musician on Maxwell Street. (Courtesy of Mary Somogy, by Cornel Somogy, c. 1962-68.)

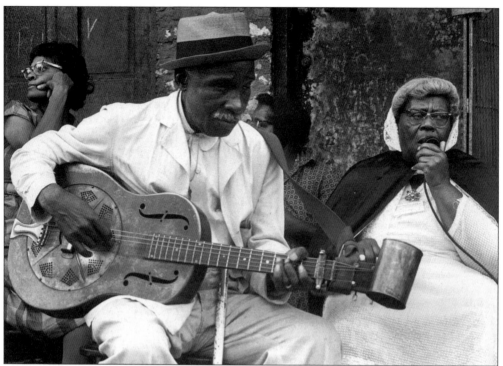

This is likely a gospel band fronted by Jim Brewer, on guitar, center. (Courtesy of photographer Jack Davis, c. 1965.)

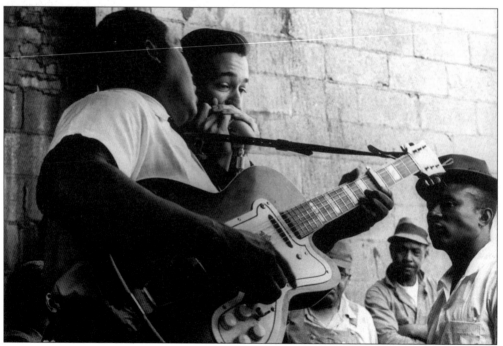

Unidentified musicians are pictured here on Maxwell Street, c. 1965. (Courtesy of photographer Jack Davis.)

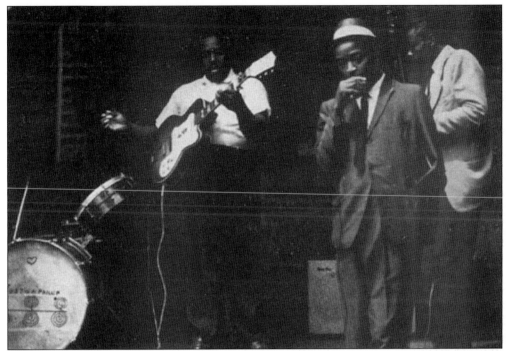

This unidentified band played on Maxwell Street, *c.* 1960s. (Courtesy of photographer Peter Welding.)

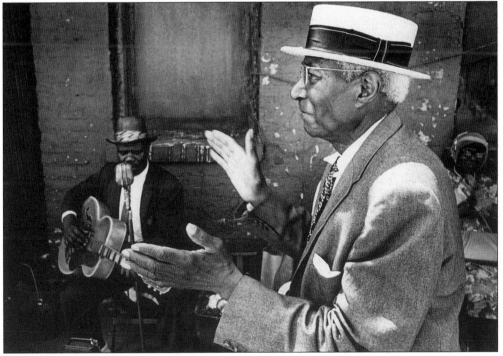

Pictured above is a man in a straw boater hat on Peoria Street east of Maxwell Street, 1966. (Courtesy of the CHS, ICHi-25652 by James Newberry.)

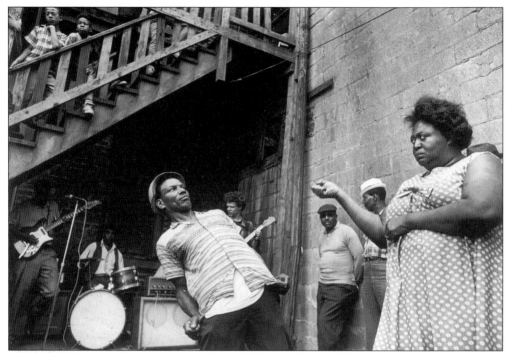

Pictured here are dancers on Sangamon Street near 14th, 1966. (Courtesy of the CHS, ICHi-35009 by James Newberry.)

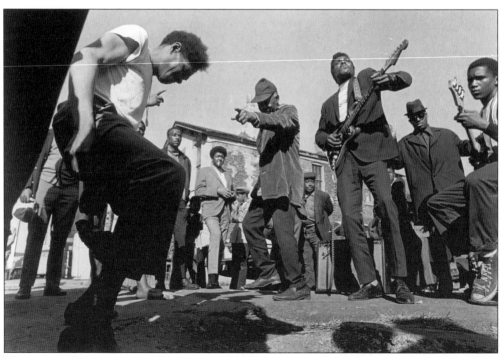

This picture shows music and dancing with L'il Pat on Peoria Street between Maxwell and 14th Streets, 1971. (Courtesy of the CHS, ICHi-35012, by James Newberry.)

A man and woman are pictured here dancing on Peoria Street between Maxwell and 14th Streets in 1970. (Courtesy of the CHS, ICHi-35008 by James Newberry.)

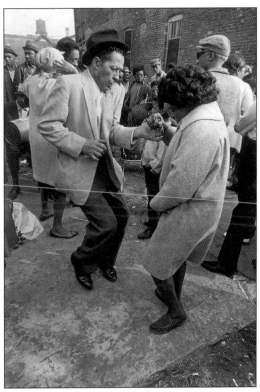

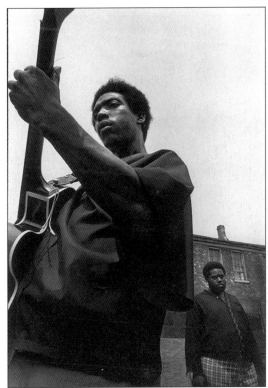

This unidentified musician is pictured *c.* 1970. (Courtesy of the CHS, ICHi-20331 by James Newberry.)

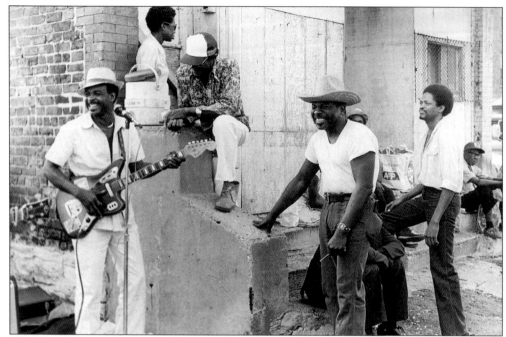

Riler "Ice Man" Robinson stands, wearing the hat, on the right. He came to Chicago in the mid-1950s, worked for years at a meat-packing job, and has played the Maxwell Street market since 1972. (Courtesy of photographer Sheila Malkind.)

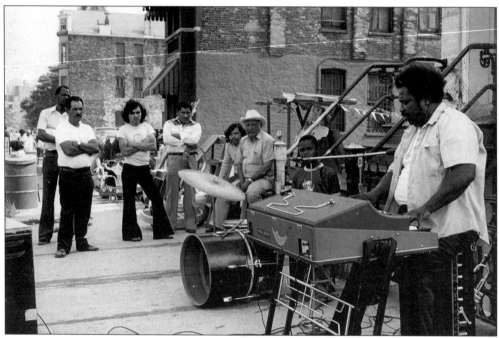

"Top Hat" Bobby Davis plays organ on the right at Maxwell and Newberry Streets. He started playing Maxwell Street in 1959 and has played with Muddy Waters, Otis Rush, Eddie Boyd, and Jimmy Rogers. (Courtesy of photographer Sheila Malkind, 1984.)

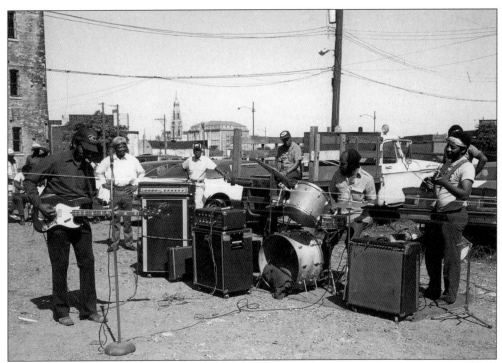

Robert "Dancin' Perkins" plays bass guitar on the left. He often worked with Maxwell Street's Jimmy Davis and played in the area from 1965 until the old market was moved in 1994. (Courtesy of photographer James Fraher, 1986.)

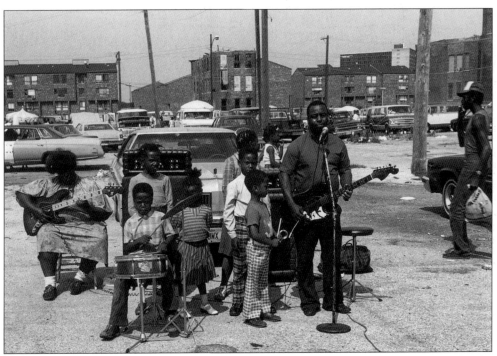

Music is a family affair near Maxwell Street, 1985. (Courtesy of photographer James Fraher.)

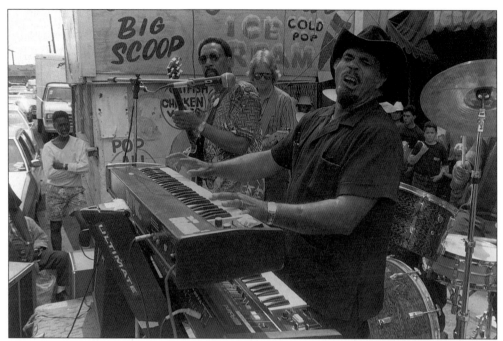

To underscore the vibrancy of Maxwell Street, even under threat of removal, Piano C. Red, right, Wayne Hatch, center, and an unidentified musician continue the tradition of outdoor blues on Maxwell Street, just east of Halsted, in front of the Johnny Dollar catfish stand in 1994. (Courtesy of the MSHPC, by Jeff Fletcher.)

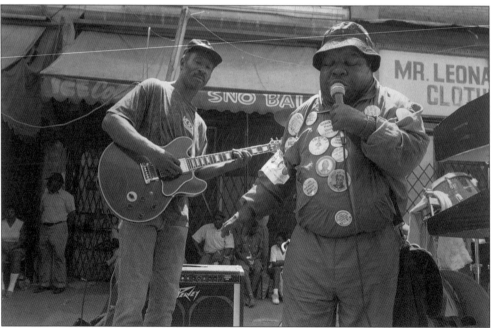

Clarence "Little Scotty" Scott sings on right, and Willie James plays on left. Little Scotty is also a community activist involved in the struggle to save Maxwell Street from the expansion of the University of Illinois at Chicago. (Courtesy of the MSHPC, by Jeff Fletcher.)

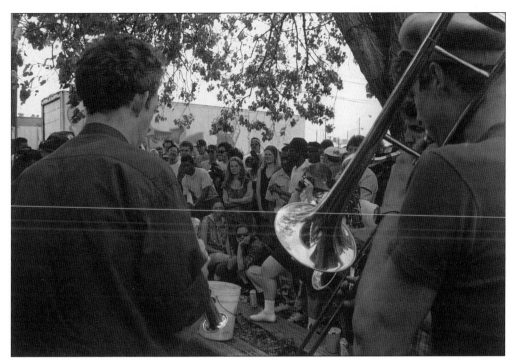

Musicians play for a crowd under the "Blues Tree" behind Nate's Deli at 807 W. Maxwell Street. The tree was removed by the university when it demolished Nate's Deli. (Courtesy of the MSHPC, by Jeff Fletcher.)

Blues woman Irma "Sugar Baby" Minzie stands by a mural of the Blues Tree at Halsted and Maxwell Streets in 1999. (Courtesy of the MSHPC, by Steven Balkin.)

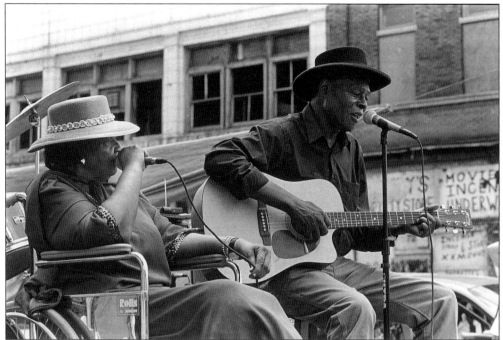

Jimmie Lee Robinson and Johnnie Mae Dunson play together on Maxwell Street. Jimmie Lee grew up near the market, played with Little Walter, Eddie Taylor, and Freddy King, and was active in the struggle to save Maxwell Street from the wrecking ball in the 1990s. Johnnie Mae Dunson started playing drums for Eddie "Porkchop" Hines while he danced on Maxwell Street and later played with and wrote songs for Jimmy Reed. She also played at blues protests to save Maxwell Street. (Courtesy of photographer James Fraher, 1999.)

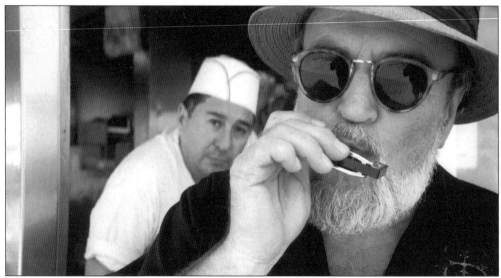

Mr. H, "the Baron of the Blues," plays harmonica in front of Jim's Original hot dog stand on its last day at Maxwell and Halsted Streets in 2001. Mr. H began playing in the area in the 1960s, and in the early 1990s was a regular at the makeshift blues stage in front of the Johnny Dollar Thrift Shop with Piano C. Red and Bobby Davis. (Courtesy of the MSHPC, by Steven Balkin.)

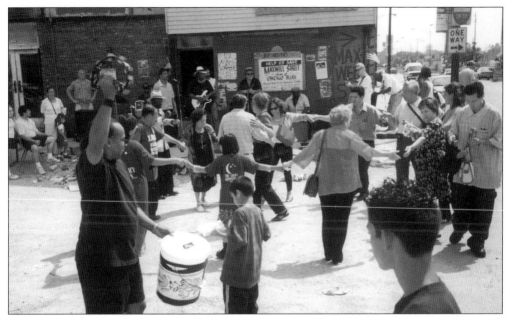

Impromptu blues jams were always the norm on Maxwell Street. The Luna's, a Mexican American family that used to live in the Maxwell Street neighborhood, dance to the blues sounds of Bobby Davis, Mr. H, and Big Willie James at a family reunion. (Courtesy of the MSHPC, by Steven Balkin, 2001.)

Frank "Little Sonny" Scott Jr. is a blues musician and folk artist who organized blues jams in the 1990s to protest the University of Illinois' expansion and destruction of the area. He is shown here with some of his folk art on Maxwell Street in 2000. (Courtesy of photographer Lee Landry.)

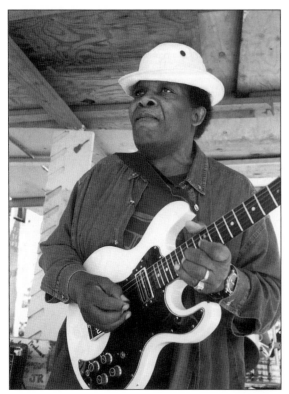

Big Willie James plays at a blues jam protest at the community-erected Juketown Community Bandstand at Maxwell and Halsted in 2000. (Courtesy of the MSHPC, by Steven Balkin.)

Lady Regina, a blues singer, wears a "Save Maxwell Street" T-shirt. (Courtesy of the MSHPC, by Steven Balkin.)

Four

URBAN RENEWAL AND COMMUNITY STRUGGLE

Maxwell Street has been altered by a number of urban renewal projects, most recently and irrevocably by the expansion of the University of Illinois at Chicago. Throughout these displacements, many members of wide-ranging communities have rallied to save the vitality and culture of the area.

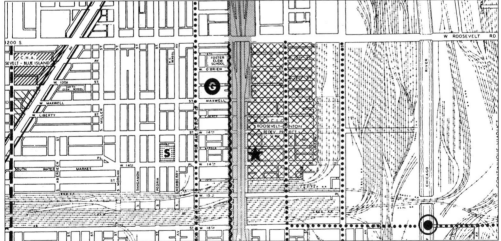

This map shows planned urban renewal projects on the Near West Side in 1958. The Chicago Land Clearance Commission designated parts of the Maxwell Street area a slum and blighted in 1955, and the city approved the Roosevelt-Clinton redevelopment project, which included the market area east of Union Street. This project cleared 46 acres, including land for the Dan Ryan expressway. (Courtesy of the CHS, ICHi-35144, Map #2094, Public Improvements, City of Chicago, Section 11, Sheet 23, January 1958.)

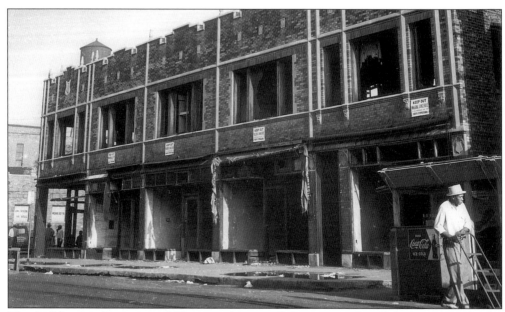

This building at the corner of Union and Maxwell Streets was demolished in 1957 for the building of the South expressway, later named the Dan Ryan. The expressway removed the eastern portion of Maxwell Street, just as the straightening of the south branch of the Chicago River had eliminated its first few blocks in 1926. In 2002, Maxwell Street runs between Union Street and Blue Island Avenue. However, it is interrupted by the university's housing development at Halsted to the Maxwell Police Street Police Station at Morgan Street. When the redevelopment is completed, Maxwell Street will no longer be the thoroughfare for the masses that it once was. (Courtesy of the CHS, ICHi-35141, by Carol Rice.)

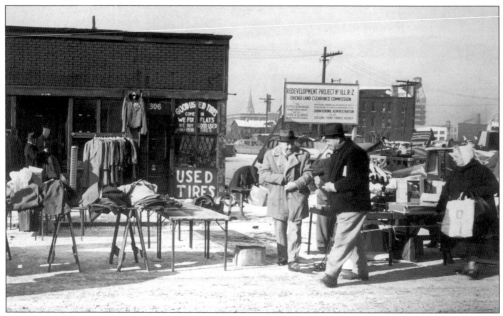

This sign announcing land clearance for urban renewal dates to 1959. (Courtesy of the CHS, ICHi-34475.)

Florence Scala led the fight against Mayor Richard J. Daley's selection of the Harrison-Halsted site for the University of Illinois Chicago Circle campus in the early 1960s. Scala was a member of the citizen Near West Side Planning Board that was planning residential development for the site until the city and university announced their plans. Scala led mostly Italian-American women in protests and an unsuccessful legal fight. Daley was embarrassed by the protests, but considered the campus, which opened in 1965, one of his greatest achievements. Over 14,000 residents, mostly Italian and Mexican, and 800 businesses were displaced. (Courtesy of the CHS, ICHi-35116, *Chicago Scene* magazine, 1964.)

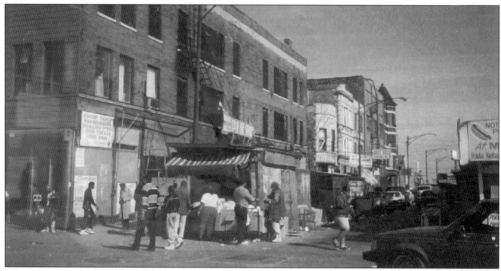

In 1990, the University of Illinois at Chicago (UIC) announced plans to obtain land south of Roosevelt Road for their south campus expansion, to include a College of Business, student residences, a performing arts complex, and playing fields. City sanitation for the neighborhood was cut and police staff was decreased. UIC began fencing off their property to "keep it clean." Residents and businesses accused UIC and the city of the creation of dirt through neglect. In 1992, the Department of Planning admitted 25 years of city neglect at the old market when Roosevelt-Canal area merchants protested the selection of their area for the new market location. (Courtesy of photographer Dan Miller, c. 1990.)

Preservationists soon realized that appeals about the folk nature of the low-income, racially-mixed community and the value of the alternative economy clearly weren't compatible with UIC goals for the transformation of these public spaces to a controlled, clean aesthetic. Therefore, they turned to focus on the area's buildings, submitting a nomination to the Illinois Historic Sites Advisory Council (IHSAC) for a Maxwell Street Market Historic District, based on the significance of 75 historic buildings. The State Historic Preservation Officer rejected it even though the IHSAC voted unanimously that the district was eligible. This vendor from Belize sells T-shirts and sundries in front of Jim's Original hot dog stand. (Courtesy of the MSHPC, by Steven Balkin, 1994.)

The Maxwell Street Vendors Association held an evening novena for the intercession of the Virgin Mary, for nine nights in August of 1994, on Maxwell Street just west of Halsted. They gathered to sing and light candles, praying to save the market, as it "accepts all, serves all, and helps us learn to get along with our brothers and sisters … that the people of the market not be split apart; and that even the poorest can work and be among us." (Courtesy of the MSHPC, by Steven Balkin.)

Market vendors and their families fight the Maxwell Street market's removal at a protest at the Daley Plaza in downtown Chicago. Vendors feared regulations that would cut their numbers in half at the new location. (Courtesy of the MSHPC, by Steven Balkin, 1994.)

Protesters carry fliers depicting Alderman Ted Mazola of the 1st Ward with Pinocchio's long nose—Mazola backed the plan to move the market. In 2001, after returning to life as a private citizen, he was awarded exclusive realty rights to the residential sales in the University Village development built on the old market site. (Courtesy of the MSHPC, by Jeff Fletcher, 1994.)

Alderman Dexter Watson from the 27th Ward appears at a "Save Maxwell Street" protest at the Chicago Blues Festival in 1994. At a Chicago City Council meeting on April 13, 1994, he criticized Alderman Ted Mazola for being insensitive to poor minorities in his support of the move of the market. Mazola jumped to respond, and his microphone was off, so he grabbed Watson's out of his hands. A tussle ensued and police broke up the fight, with vendors cheering on Watson. The city council, by a 34-10 vote, agreed to the South Campus expansion plan, the relocation of the market to Canal Street, and the sale of city land to UIC, knowing that some 400 vendors would be barred from the new market. (Courtesy of the MSHPC, by Jeff Fletcher.)

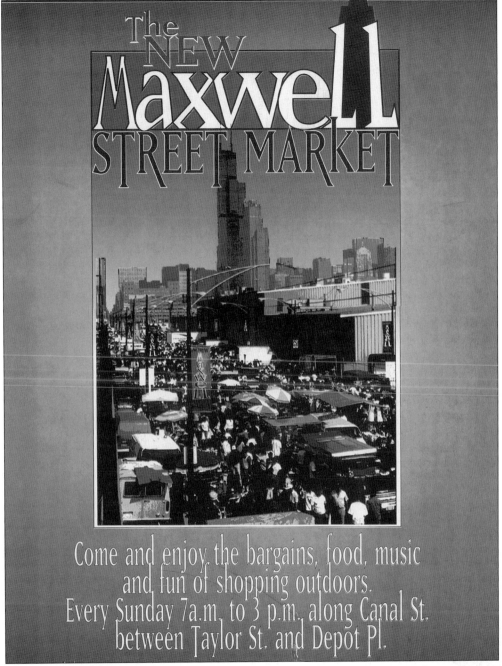

The NEW Maxwell STREET MARKET

Come and enjoy the bargains, food, music and fun of shopping outdoors. Every Sunday 7 a.m. to 3 p.m. along Canal St. between Taylor St. and Depot Pl.

Pictured is a poster promoting the New Maxwell Street Market, which opened September 4, 1994, on Canal Street north and south of Roosevelt Road. The new market was designed to be regulated and rational, as opposed to the unruly, informal nature of the old market. The city's Department of Consumer Services emphasizes cleanliness and safety to eliminate the "bad" elements of the old market, while Ravenswood Special Events attempts to recreate what they see as the "good" parts of the old market with music, food, and placement of vendors. (Courtesy of the City of Chicago's Department of Consumer Services.)

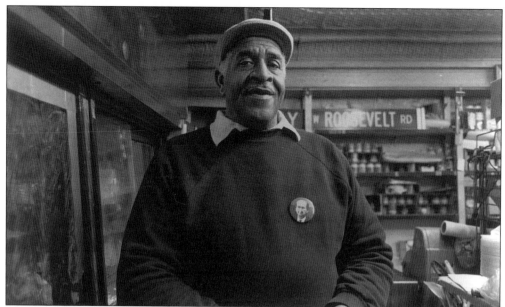

Nate Duncan had worked in Lyon's Delicatessen for over 25 years when he bought it from Ben Lyon in 1973. For over 20 years he continued to serve kosher food there, musicians played at the Blues Tree in back, and the old market's last market master had his "office" at one of the tables. Nate's Deli was also the Soul Food Café where Aretha Franklin sang "Think" in the 1980 film *The Blues Brothers*. (Courtesy of the MSHPC, by Jeff Fletcher, 1994.)

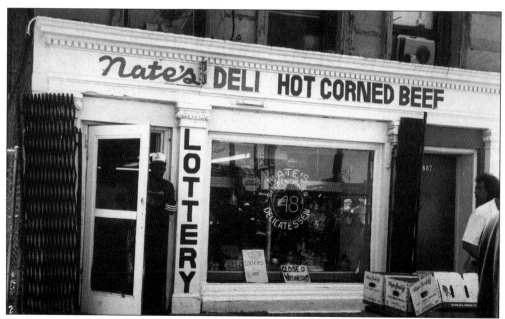

In the early 1990s, UIC began to buy property in the area, tacitly using the threat of future powers of eminent domain. Many owners stopped putting money into their properties because of the threat of removal, giving credence to UIC's rhetoric of blight. Nate's Delicatessen, a neighborhood institution at 807 W. Maxwell, was one of the early sales and closed in 1995. (Courtesy of the MSHPC, by Steven Balkin.)

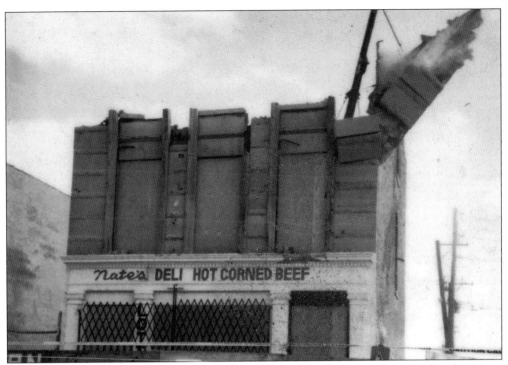

Picture above is the destruction of a landmark—the demolition of Nate's Deli. The Marie Robinson Residence Hall now stands on the site. (Courtesy of photographer Merlyn McFarland, 1995.)

An underutilized UIC parking lot was built on the site of Nate's Deli after demolition to hold the land for development. The sign reflects the community feeling that UIC never welcomed input or requests for inclusion and that UIC chose to displace a community wholesale as they had when they arrived in the 1960s. In 1996, the Illinois General Assembly granted UIC eminent domain power in the Maxwell Street area. (Courtesy of the MSHPC, by Steven Balkin.)

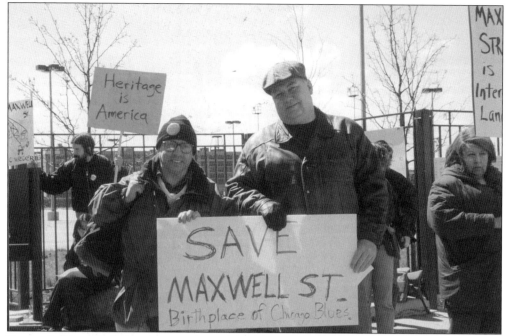

Steven Balkin, left, is the vice-president of the Maxwell Street Historic Preservation Coalition (MSHPC) and a professor of economics at Roosevelt University. Chuck Cowdery, right, is the president of the MSHPC and a lawyer and historian of the blues. The MSHPC submitted two attempts for historic preservation status for the area. (Courtesy of the MSHPC, 1998.)

Frank Williams is a community activist who worked early on in the fight to save Maxwell Street in conjunction with his efforts to ensure that ABLA residents (Addams, Brooks, Loomis and Abbott public housing) were not displaced by powerful interests. The ABLA Homes are in close proximity to UIC along Taylor Street and Blue Island and are in the process of being dismantled. (Courtesy of the MSHPC, by Steven Balkin, 1995.)

Merlyn McFarland, shown here kissing his friend "Little Mama," is known as the "Mayor of Maxwell Street" because he lived in the neighborhood, is a vendor, and served as the caretaker of the area. He also served as the eyes and ears of the street for preservation efforts. (Courtesy of the MSHPC, by Steven Balkin, 1999.)

Tyner White, of Maxwood Institute, is a Maxwell Street activist interested in the reutilization of urban lumber and scrap carpentry. He was a resident of the Maxworks Co-operative formerly at 716 W. Maxwell Street, which has also been a locus of activity for the Chicago Greens. He is shown here with a stradozuki instrument, one of his inventions. (Courtesy of the MSHPC, by Steven Balkin, 1999.)

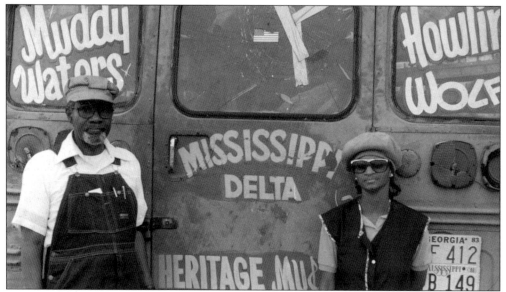

Reverend John Johnson, Marie Johnson, and their Blues Bus, from which they sell blues recordings, have been an important presence at the old and new market. The Johnson's are MSHPC members and also sold music from Heritage Blues Bus Records at 1318 S. Halsted Street, which the Coalition used as a mini-museum. They are still asking for the opportunity to do business in the redeveloped neighborhood. (Courtesy of photographer Linda Baskin, 1994.)

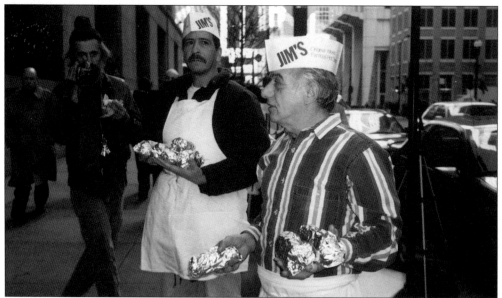

Employees from Jim's Original hand out free Polish sausages at a protest at City Hall. The message was for UIC to include Maxwell Street businesses in their redevelopment plans and to renovate, rather than destroy, the buildings in the Maxwell-Halsted district. The Stefanovic family that owns and operates Jim's has been active in the MSHPC, and pressure from this group pushed UIC to preserve the shells of eight buildings and thirteen facades along Maxwell and Halsted Streets for adaptive re-use. Jim's is one of the few businesses the university will include in their plans. (Courtesy of the MSHPC, by Steven Balkin, 1998.)

As UIC submitted its South Campus expansion plans to the city for approval in 1998, they held community meetings offering up jobs and minority construction contracts. Frank "Little Sonny" Scott Jr. speaks at City Hall for most community members, who were not receptive. The city approved the plans, and the following year approved a set of tax increment financing (TIF) and redevelopment ordinances for the project. Community activist and videographer, Lorenz Joseph Lessin, is shown on the right. (Courtesy of the MSHPC, by Steven Balkin.)

In 1998, the city developed an ad-hoc committee on the fate of Maxwell Street due to pressure from preservationists. UIC and city planners, architects Howard Decker and John Vinci, and MSHPC members took part, with preservationists advocating rehabbing existing buildings, citing the positive outcomes on Memphis's Beale Street and on Manhattan's Lower East Side historic district. They brokered a compromise based on the architects' recommendation to save 36 buildings out of the 60 remaining. Another assessment by the city-hired consultant McClier Corp. recommended 27 buildings be saved, but UIC reneged on these agreements. Here, MSHPC board members Elliot Zashin, Bill Lavicka, and Alan Mamoser attempt to hold UIC accountable at a UIC Board of Trustees meeting. (Courtesy of the MSHPC, by Steven Balkin.)

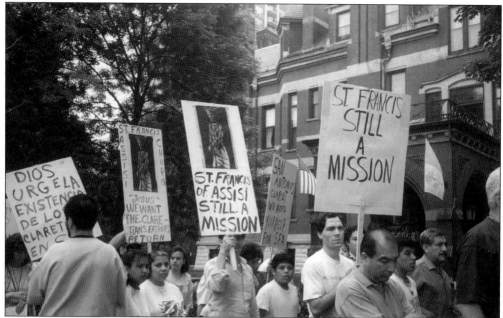

St. Francis of Assisi parishioners march in front of Cardinal Bernardin's residence to protest the closing of their church by the Archdiocese for the selling of its land. The church, at Roosevelt Road and Newberry Avenue, has been the locus of the Mexican-American community on the Near West Side since the 1920s and continues to draw 5,000 parishioners weekly from all over the city. (Courtesy of the MSHPC, by Steven Balkin.)

Devoted parishioners occupy St. Francis of Assisi Church 24 hours a day in the sub-zero cold of February, 1996 to prevent its demolition. The Chicago Archdiocese closed and began to demolish the church, but after months of constant occupation, they relented and reopened the church in April of 1996. (Courtesy of the MSHPC, by Steven Balkin.)

A stained glass window in St. Francis of Assisi Church commemorates the parishioners' occupation of the church to save it during the bitter winter of 1996. (Courtesy of the MSHPC, by Steven Balkin.)

Children with flowers line the aisles waiting for Cardinal George to rededicate St. Francis of Assisi in 1997. Cardinal George's parents were married in the church when it was a German parish. The rededication was a victory for a community's assertion of their continuing place in the Maxwell Street neighborhood. (Courtesy of the MSHPC, by Steven Balkin.)

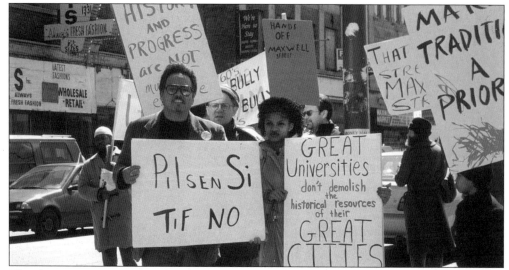

This demonstration was aimed at the Roosevelt-Halsted TIF (tax increment financing), worth $55 million, that the university applied for in the area. TIF provides incentives for private developers to develop "blighted" areas by allowing projected future increases in real estate taxes to pay for infrastructure improvements and developer subsidies. The sign held by activist David Aragon refers to a TIF proposed for Pilsen, a Mexican-American neighborhood next door, perceived as a threat by community members who fear displacement by interests from outside the neighborhood. (Courtesy of the MSHPC, by Steven Balkin, 1998.)

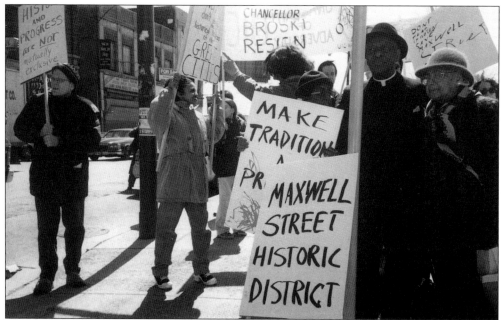

The same demonstration is attended by Bishop John D. Walker on the right, elder at the Gethsemane Missionary Baptist Church, one of the institutions threatened by UIC expansion. Activists fought the TIF application because they felt UIC had contributed to the area's "blighted" status, and because developers will be using tax revenues to subsidize upscale townhouses and to replace current businesses. (Courtesy of the MSHPC, by Steven Balkin.)

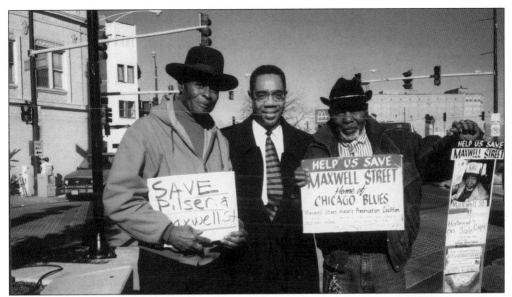

Jimmy Lee Robinson and Frank "Little Sonny" Scott Jr., musicians and MSHPC members, attend a rally for mayoral candidate and Congressman Bobby L. Rush, center, in 1998. Rush who lost to Mayor Richard M. Daley, is known for his beautification efforts in the city. Rush claimed that these projects often direct resources towards affluent communities and displace less affluent populations. The MSHPC contends that UIC and city discourse about beautification and disorder, or "dirt and danger," could be read as messages intended to exclude certain racial and economic groups. (Courtesy of the MSHPC, by Steven Balkin.)

Blues musicians were among the most committed activists for Maxwell Street, especially Frank "Little Sonny" Scott Jr. ("Supreme Mayor of Maxwell Street") at left, and Jimmie Lee Robinson ("King of Maxwell Street") at right, shown here during Robinson's hunger strike for Maxwell Street which lasted 81 days. (Courtesy of the MSHPC, by Steven Balkin, 2000.)

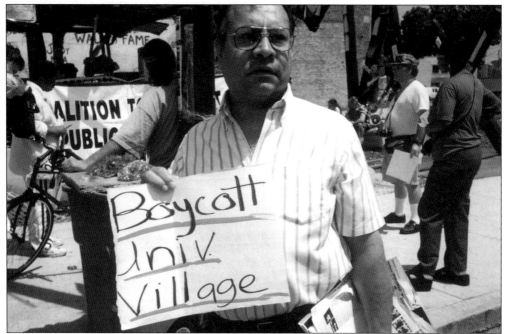

Gerardo Reyes, president of the St. Francis of Assisi Preservation Committee, holds a sign at a protest at the Juketown Community bandstand to discourage investment in the UIC's profitable residential development going up in the area. (Courtesy of the Maxwell Street Historic Preservation Coalition, by Steven Balkin, 2000.)

Lenore, a resident of Maxwell Street, is shown here by her continually updated art fence, which was periodically dismantled by UIC. (Courtesy of the MSHPC, by Steven Balkin, 1999.)

Mohammed, a Maxwell Street incense vendor, with his father, a peanut vendor, at a protest rally at the Juketown Community bandstand. (Courtesy of the MSHPC, by Steven Balkin, 2000.)

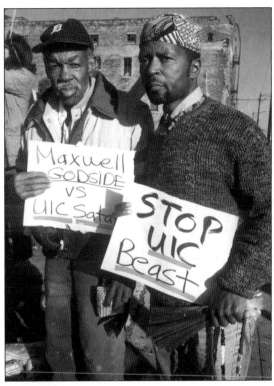

This graffiti attacks UIC's claim that the land they appropriated is for public use. Activists perceived the use of eminent domain to build private upscale residences for profit and to favor one set of retailers over another as inconsistent with a public purpose. Over 400 vendors and 40 businesses were displaced in the 1990s. (Courtesy of the MSHPC, by Steven Balkin.)

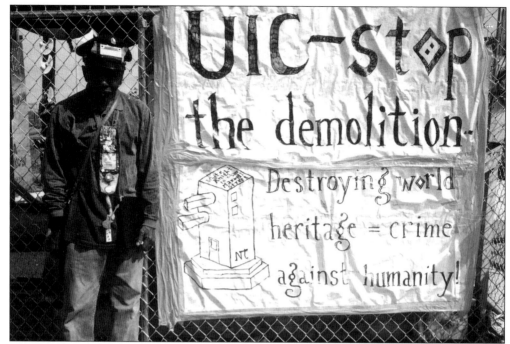

A sign on a fence protests the destruction of the heritage contained in the built environment and businesses along Maxwell and Halsted. The MSHPC tried a second time to put the district on the National Register in 2000, emphasizing post-1930 and Blues music history, but the submission was defeated. The spouses of two of UIC's private developers were on the board of the Illinois Historic Preservation Agency at that time. Frank "Little Sonny" Scott Jr. stands at left. (Courtesy of the MSPHC, by Steven Balkin, 2000.)

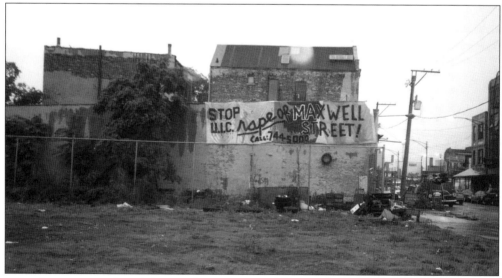

This sign conveys the violation the community felt at the secrecy and aggression that characterized UIC's handling of the south campus expansion, resulting in the displacement of residents and businesses and the destruction of history. (Maxwell near Union Street, 1998. Courtesy of the MSHPC, by Steven Balkin.)

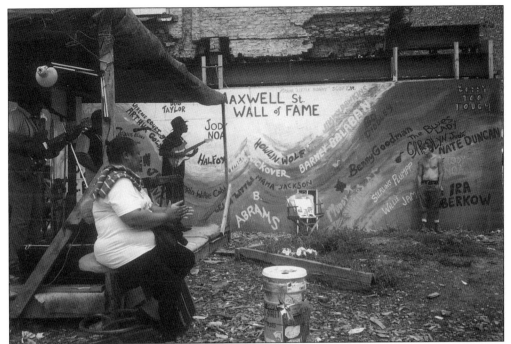

The MSHPC created public art and performance space at the corner of Maxwell and Halsted Streets to combat perceptions of blight. The Maxwell Street Wall of Fame mural showcased names of well-known people with connections to Maxwell Street, and the Juketown Community Bandstand held blues jams on a regular basis. (Courtesy of the MSHPC, by Steven Balkin, 1999.)

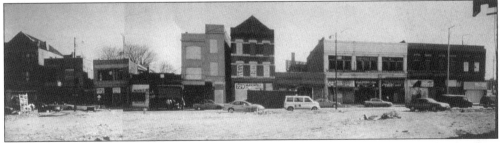

A view of the 700 block of W. Maxwell Street (the south side of Maxwell east of Halsted) in 2000 shows the successful acquisition and boarding up by UIC of much of the property on that block. Community activists called this plan blight. (Courtesy of the MSHPC, by Steven Balkin.)

The Maxwell Street Historic Preservation Coalition led many walking tours of the neighborhood to showcase the area's history and vitality in the face of destruction. Here, Lori Grove (on right), tour director for the Chicago Architecture Foundation's Historic Maxwell Street neighborhood tour, leads a group down Halsted Street. (Courtesy of the MSHPC, by Steven Balkin, 2001.)

Filmmaker Wim Wenders talks to musician Bobby "Top Hat" Davis while filming for a PBS Blues documentary. The bustling atmosphere of Maxwell Street has been featured in many films, ranging from the 1964 documentary *And This Is Free* by Mike Shea to a memorable scene in the 1980 movie *The Blues Brothers*. Maxwell Street was also the setting for the 1947 novel *Knock on Any Door*, made into a movie starring Humphrey Bogart, and written by Willard Motley, an African American who moved to Maxwell Street to find the characters that would populate his writing. (Courtesy of the MSHPC, by Steven Balkin, 2001.)

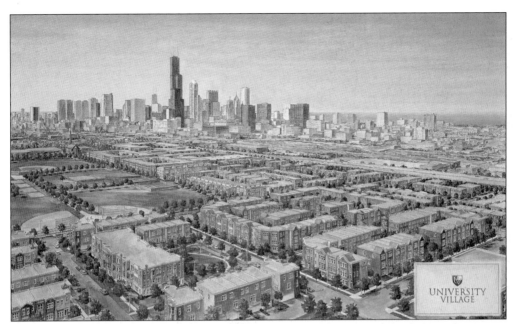

The University of Illinois's conceptual rendering of the University Village and South Campus development shows 850 condo, loft, and town-home units priced from $449,900 to $800,000 in 2002. (Courtesy of Firestar Communications, 2002.)

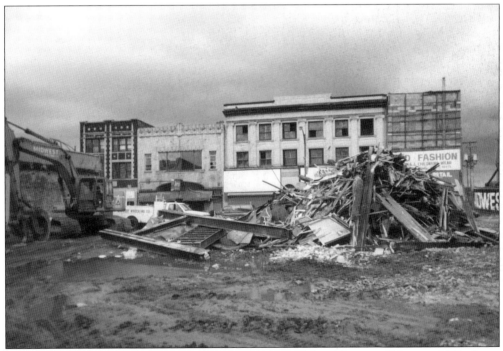

This photo, taken after the demolition of 1242–1248 S. Halsted Street in February, 2001, shows the 1200 block of South Halsted looking east. (Courtesy of photographer Steve Sexton.)

The old 7th District Police Station, in service until 1945, is the only building that UIC was initially committed to saving. It was placed on the National Register in 1996. This Richardsonian Romanesque-style building from 1888, on the southeast corner of Maxwell and Morgan Streets, is a link to the police history, labor clashes, and criminal activity around the Maxwell Street area. The exterior of the building was the fictional police station in the 1980s television show *Hill Street Blues*. (Courtesy of the CHS, ICHi-35002, by David Sacks.)

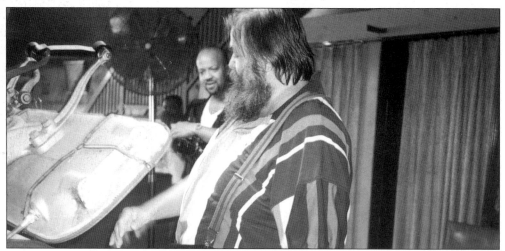

The last business on Maxwell Street was Paul and Bill's Tailor shop at 719 W. Maxwell Street. Slawko Olenczuk, the owner, stands in the foreground with the press and photographer Lee Landry appears in the background. As of July 2002, Olenczuk has lost his fight in court to stay in the area, even though it would seem that a tailoring business is compatible with retail needs for a university campus. (Courtesy of the MSHPC, by Steven Balkin, 2000.)

This conceptual rendering shows UIC's vision for Maxwell Street just east of Halsted, where there will be retail of the university's choosing and façades from demolished area buildings placed on the front of two parking garages joined by a turreted bridge. Preservationists criticize this vision of Maxwell Street as "façadism" and a corporate, in-authentic place planned to simulate an "old-time" feel. (Courtesy of Firestar Communications, 2002.)

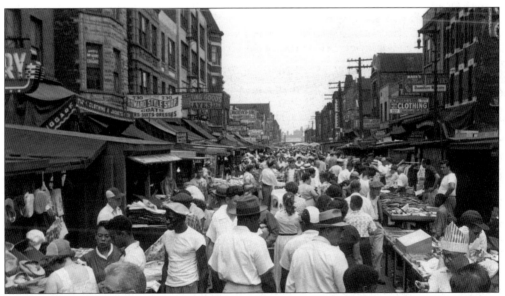

In stark contrast to UIC's plan, this 1950s view (just east of Halsted, as in the top photo) shows the hustle-bustle of the historic street market that was the essence of Maxwell Street's atmosphere. The combined mix of people, sights, sounds, and smells within the authentic streetscape and marketplace, is what composed Chicago's Maxwell Street. With the arrival of the 21st century, Maxwell Street is once again transformed, but its essence is now preserved in the images of its significant past. (Courtesy of Edward C. Schulz, 1954.)